Capturing Personality in Pastel

Capturing Personality in Pastel

by Dennis Frost

WATSON-GUPTILL/NEW YORK

To Pat, who is special.

First published 1982 in the United States and Canada by Watson-Guptill Publications,
a division of Billboard Publications, Inc.,
1515 Broadway, New York, N.Y. 10036

Library of Congress Cataloging in Publication Data
Frost, Dennis, 1925–
 Capturing personality in pastel.
 Includes index.
 1. Pastel drawing—Technique. 2. Portrait
drawing—Technique. I. Title.
NC880.F7 1982 741.2'35 81-21935
ISBN 0-8230-0560-7 AACR2

Manufactured in Japan

1 2 3 4 5 6 7 8 9/86 85 84 83 82

Edited by Bonnie Silverstein
Designed by Jay Anning
Graphic production by Ellen Greene
Set in 12-point Palatino

In Memorium

After this book was written, and all during the lengthy editorial process that followed, Dennis Frost fought a desperate battle with cancer. Nonetheless, Frost believed in this book and realized its importance and, despite his pain, he and his kind wife Pat actively aided Watson-Guptill as we worked on the book, checking galleys, making suggestions, and offering generous support. Then, on February 4, 1982, just as this book was going to press, Dennis Frost died. We sadly wish he could have lived long enough to see this book. Dennis Frost will always be remembered with great affection and respect by those fortunate to know him personally, but we, his readers, must be content with knowing him through but a small part of his work—this book.

The Editors

Acknowledgments
To my very good friends Ernest Savage, V.P., P.S., and Marjorie, for their unstinting help and encouragement, always so generously given.

To Violet Bibby, writer and painter, for all her help.

To David Lewis, whose suggestions, infectious enthusiasm, and hard work made this book possible.

Contents

Foreword

By Ernest Savage

Pastel is an enchanting medium that is attracting an increasingly large number of enthusiasts to its versatility and charm. So the advent of another instructional book on pastel is of some significance. Its publication is doubly welcome since it has been written and illustrated by the talented Dennis Frost, a valued colleague and member of the Pastel Society. It thus gives me great pleasure to write a foreword to this new book, *Capturing Personality in Pastel.* It should do much to further this growing interest in pastel and, in particular, encourage and help to develop the skills of those who wish to use pastel for portraiture.

Pastel is a versatile medium, one capable of wide interpretation and suitable for a full range of subject matter. Since pastel can be applied instantly, it lends itself to lively and direct treatment, resulting in that lustrous and velvety bloom so beloved by its admirers. These stimulating properties make it especially popular for portraiture, as evidenced by Dennis Frost's own work. The book offers a great deal of helpful advice to the intermediate and advanced portrait pastellist struggling to attain vitality of technique and confident competence in his work. The author's teaching is sound: He reiterates the importance of pre-planning, observational sketches, good initial drafting, a gradual build-up toward good tonal values, and a final understatement of accents, all of which are admirably depicted in the demonstrations that profusely illustrate his book.

Dennis Frost's art is both inspirational and informative, and you may even wish to study individual works through a magnifying glass to approximate their appearance at actual size. Frost not only shows an exciting command of pastel technique, but he also brings a remarkably high degree of sensitivity to his portraits, especially those of the aged and of those subjects with strong characteristics. Much of his success is also due to his sincere and honest approach: his modest attitude and willingness to discuss and analyze certain difficulties—and what he calls "bad habits." These excellent qualities, plus his emphasis on self-discipline, makes Frost a worthy model for emulation in your search for artistic progress.

Ernest Savage
Vice President, Pastel Society
Fittleworth, England, 1981

Introduction

As a professional portrait painter, most of my pastel painting is commissioned work where my subjects are not my own choice and may not be a challenge to paint. However, the majority of my *character* portraits are of people I chose to paint for my own pleasure, and I find that tackling an intriguing personality in pastel gives me great satisfaction in painting as an outlet for emotional expression.

In my constant search for suitable subjects, I find that interest is created not only by features and expressions, but also by the posture—an awkward stance, a turn of the head, or an exaggerated gesture. The individual style in such mannerisms is a recognizable characteristic, and when it is presented in an accurate and clear way, such mannerisms can form the basis of an interpretation that is both intriguing and human.

When confronted with an inspiring face or figure, I first study the subject and try to determine which characteristics are so striking. My interest may be in a facial expression or a quality in the eyes or the mouth. I may also be sparked by a plea for sympathy in an aged face or by the warmth generated in a child's radiant smile. It may even be the resigned stoop of an old man or the pigeon-toed stance of a daydreaming little girl. Whatever it is, certain human expressions—extremely unhappy or deliriously excited expressions for example—communicate themselves strongly and after years of study I have learned to apply them to a portrait to solicit a response from the viewer. But there is more to creating personality in pastel than merely creating an accurate interpretation of the "easy bits"—the eyes, mouth, and hands. With experience and much practice, you will find more subtle ways to telegraph personality and character. Using pastel and paper, and with careful observation, you can make shape, tonal value, texture, and color indicate character. This, plus knowing *when* and *how much* to emphasize or play down a feature, will make a painting successful.

It would be relatively easy for me to earn a living by painting smooth-skinned, rosy-cheeked, smiling children, or dewy-eyed, silky-haired puppies or kittens. These romantic stereotypes are easily communicated in pastel. But painting them would offer no inspiring challenges or new painting problems to solve, no sense of adventure, and above all, no chance to do a painting that would be better than any I had done before.

Painting non-commissioned portraits, on the other hand, gives me the opportunity to disregard the stringent limitations of getting an accurate likeness. Each character I choose to paint offers a challenge to convey the finer nuances of personality through pastel. In a non-commissioned

portrait I am free to search for characteristics that show an interesting disposition and make a startling painting that results from my own interpretation of that personality. I am not forced to aim for simply a good likeness that would have been far more easily achieved with a snapshot. And if I should wish to add or remove eyeglasses or a beard from my subject to create a stronger character, I do it. This also frees me to produce more impressionistic and spontaneous paintings.

When confronted with a face or figure that seems likely to yield a good painting because of its strength, frailty, or mischievousness, I have to pluck up the courage to approach the person and persuade him or her to sit for a portrait. I also use a camera with a telescopic lens—and my scrapbook bulges with photographs of stolen expressions and un-selfconscious mannerisms. Sometimes these photographs are an entirely adequate source of inspiration, but usually painting a live person produces the most reward.

Sadly though, I have come to the conclusion that faces do not always mirror the personalities of their owners. I have been charmed many times by the gentle nature of the most villainous-looking person, and alarmed by the overbearing personality hidden behind a sweet, gentle aspect.

My first introduction to pastel came when I joined a portrait painting class where the tutor demonstrated pastel as a medium. I had been learning to paint in oil at the time and was struggling manfully with tonal values, color mixing, and brushwork; juggling with various oil mediums and brushes; and experiencing the joys of learning to stretch canvas. After facing this morass of bottles and tubes, I was staggered by the simplicity and directness of pastel and the shortcuts it seemed to offer. Never mind the superb pastels of Degas, Sargent, or Whistler—with ready-to-use sticks of pastel, I could get on with the painting!

In retrospect, the only real shortcuts were the chalk form of the medium and the immediate color it offered. I had to learn everything else for myself and make all the usual beginner's mistakes. But pastel offered me the real challenge of attempting to suggest a personality, a way of life, a quality, an eccentricity, or perhaps a reputation with a few chalk pastels and a sheet of paper. In this book, I will show you examples of the way I work. I feel that some of my paintings are successful in that they do convey the personalities I strived to paint. Although I shall never know whether you will also view these personalities as real characters, I experienced the excitement, pleasure, frustration, and despair of painting them and in this process, each painting, for me, became a character.

Practical Working Methods

Materials

Pastels

I use two brands of pastel, Rowney's Soft Artists Pastels and the Rembrandt range manufactured by Talens. Both are of excellent quality and I recommend them to you for portrait work. In the Appendix, you will find a chart that matches equivalent Rowney and Rembrandt pastels, color for color. However, throughout the book, I have given the tint reference of the Rembrandt pastel in parenthesis for the Rowney pastels I used for each painting.

Paper

I use an inexpensive Canson Ingres paper of a middle-value gray, named Tint 55. It is a good all-round support, with just enough tooth to hold a generous pastel mark and of a color that gives an excellent, basic, middle value from which to work up to the highlights and down to the darkest tones.

Easel

It is important to let excess pastel dust fall off the paper, so I use an upright, sturdy easel, one heavy enough to resist the pressure of firm pastel strokes. During the course of a painting, I periodically tap the surface to encourage the loose particles of pastel to fall downward and off the paper to make sure that the only color remaining on the paper is that which is permanently adhered.

On the easel I suggest you use a good-size drawing board, one at least half an inch (13 mm) thick and not less than 24″ × 32″ (60 × 80 cm) in size. It is also a good idea to place several sheets of flat paper under your work sheet to give a resilience to the pastel strokes and to provide a cushion that will eliminate any imperfections that may show through from the surface of the drawing board.

Taboret

My working pastels are laid out on the top shelf of an old tea cart. The lower shelf holds a large jar of ground rice into which I drop my dirty pastels at the end of the day. A gentle shake in the rice for a few moments cleans the pastels of the dust that accumulated during the painting session. I also keep a piece of coarsely woven rug canvas for use as a sieve.

Mounts

I keep a stack of mats in a range of sizes and colors in the corner of my attic studio to help me resolve composition or color problems as I paint. Two large L-shaped mats are especially useful in deciding the exact framing of a painting.

Mirror

I keep a small hand mirror nearby while painting and occasionally glance in it to spot faults I may not have noticed in looking at the work straight on. Seeing the painting in reverse offers a fresh point of view.

When painting a live subject, I also stand back from the work regularly and study the painting and the model together as a unit. This enables me to evaluate the picture as a whole, rather than simply see the details.

Varnish brush

I find a 2″ (5 cm) varnishing brush ideal for removing a little or nearly all pastel from the paper. I also brush it gently over the painting to produce a graduated pastel background, removing only a little of the pastel at a time.

I also use it to correct a painting. By brushing it vigorously over the pastel all but the most deeply ingrained pastel will lift off. The re-application of pastel will usually obliterate the remaining color, leaving no trace of the original painting.

Fixative

I use fixative to preserve certain stages of a pastel. For example, if the basic outline is correct and I know that there is much color work to go on top of this, I fix the preliminary stage of the painting so it does not rub off or become distorted during later activity. However, I have observed that fixatives tend to lower tonal values and color in a very unequal way, thus distorting the atmosphere in a painting. And when used in a painting with extremely subtle changes in value or color, fixative can destroy the entire strength of the pastel statement.

I have also found that fixative provides no guarantee against smudging—some paintings are quite easily damaged after a careful application of fixative. So to preserve your best work, either keep it in a folder with a sheet of soft tissue against the painted surface or, better still, invest in frames and mount your work under glass.

Handling Pastel
Stroke pressure

A stick of pastel is an extremely versatile painting instrument. Used end-on, it produces a narrow line of rich or thin color. Used on its side, it makes a range of strokes of different width and density. It is essential to cultivate a feel for the pastel stick, to be able to break it to the correct length, and to anticipate the degree of pressure to apply with each piece.

Breaking the pastel

When you break a pastel stick to a required length for use on its side, before you use it, wear down a flat surface along its length by rubbing it against sandpaper or a piece of paper. Otherwise, you may find that instead of the intended flat area of color you intend, you will have two or more heavy parallel lines because of the partial contact of pastel to paper.

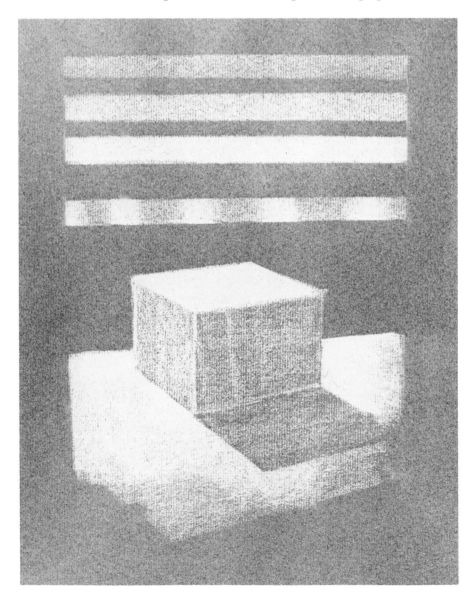

The three bars at the top show marks made by applying pastel with light, medium, and heavy pressure, respectively. The fourth stroke shows the application of alternating light and heavy pressure, which gives the appearance of form as well as tone. The simple block shape was made with areas of even pastel, applied with different pressures. The lightest pressure represents the darkest area.

Glazing

When glazing one color over another, you must make the lightest possible application so that the color underneath shows through. This skill can only be acquired through practice. On the other hand, when painting a solid mass of color, knowing how to apply the pastel with the correct density, shape, and direction will enhance your technique and give style to your work.

Paper

The paper surface plays an important part in determining the density and texture of pastel. The examples on these two pages were made on a middle value gray Canson Ingres paper, using white pastel.

Practice making pastel strokes of varying pressure. It may be a chore, but varied strokes are essential for the production of successful paintings. It is the sensitivity with which the pastel is applied to the paper that gives a painting its style and shows the confidence of the artist.

Here the pastel is used with varying pressure. To do this successfully, it is necessary to master the technique of applying graduated pressure.

Handling Pastel
Rubbing-in

Blending tones, color, and texture is achieved by rubbing-in pastel strokes. This produces a soft, velvety appearance, because the pastel is smudged into the pores of the paper, giving the work a highly finished and precise look. This works particularly well for some portraits of children and many first-rate paintings have been produced using this method.

Rubbing-in or blending can be achieved with shading stumps or "tortillions." These are prepared tools made of paper rolled into pointed, pencil-shaped forms. You will find these stumps quite useful, especially the fine-pointed variety, which can be directed with accuracy.

However, the blending instrument I most favor is the side of my little finger. It is sensitive, soft, easy to clean, and above all, never mislaid! I use the outside of the top joint, close to the nail. The blending movement is a light, caressing one that varies in pressure according to the work required, and a hard protective skin soon forms on the finger and prevents soreness. But a word of caution to the pastellist experimenting with supports: I once saw a very effective painting produced on a fine sandpaper. But when I tried it using my usual blending approach, I wound up nursing a sore finger for days! When it healed, I returned thankfully to my usual range of Canson papers.

The initial rubbing-in, or blending of pastel is usually a vigorous action designed to fill in the tooth of the paper and blend colors together. As the painting progresses with more selective blending, the action becomes more of a caress calculated to allow the colors or tones to merge with each other in a graduated manner. The strokes are arranged in the direction you want the eye to follow, and by varying the pressure of the strokes, you can create shapes that are either full and round or almost flat in appearance. You can also produce different effects ranging from the spontaneous result of a flick of your little finger to a more deliberate stroke from controlled pressure

As you begin to use your little finger for blending, you will soon become aware of the necessity for cleaning your rubbing finger constantly. Transferring the wrong color to a vital part of your picture because it was on your finger will drive the point home.

Some purists argue that excellent work can be achieved without a blending technique, and that harsher tonal changes and richer textures, color, and tones make better interpretations in pastel. But as an enthusiastic pastel painter, I use rubbing-in when it suits the painting, and leave the pastel strokes unblended when I feel that a rougher effect is necessary. For instance, I use fairly extensive rubbing-in

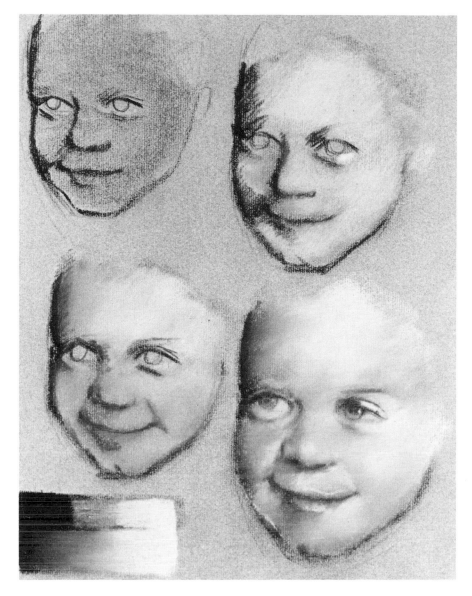

Stage 1 (top left)
I did the basic drawing in sanguine Conté crayon, with a shadow area of madder brown 8. (This number refers to a Rowney-brand pastel color. The equivalent Rembrandt color, in this case 373.3, will hereafter follow all Rowney colors, in parenthesis, throughout the book. In addition, a chart of equivalent Rowney-Rembrandt pastels is provided in the Appendix for reference.)

Stage 2 (top right)
I made a heavy application of madder brown 0 (339.9) and strengthened the shadow areas with madder brown 8 (373.3).

Stage 3 (lower left)
I applied a little poppy red (318.7) to the lips and cheeks, then vigorously blended the pastel by rubbing-in with the little finger of my painting hand. After years of working this way, I can now control the pressure of the rub-in and thus determine the density of the pastel. Note that where the rubbing-in was most pronounced, the texture of the paper has almost disappeared.

Stage 4 (lower right)
Details were added to the eyes and mouth with madder brown 0 (339.9) and a little white was used for highlights and to reveal the form. The white has been rubbed-in so the edges of each stroke disappear gradually into the surrounding color.

Color bars (extreme lower left)
The color bars show madder brown 0 (339.9) and 8 (373.3) and sanguine Conté crayon blended roughly at the top and rubbed-in gently below, giving a fine gradation of tone.

during the early stages of a portrait because I like to cover the area with a basic color and tone. Then, as the painting develops, I rub-in the pastel less often and less thoroughly, allowing the texture of the paper to show through. At the end, I let the final touches, such as fine lines or individual dots remain as simple, pastel marks. (Instead of rubbing-in during the first stage, some painters prefer to mix the pastel with other media and accordingly prepare areas for pastel overpainting with tones of watercolor, gouache, or ink.)

Since pastel cannot be mixed on the palette beforehand like other media, you must mix your colors directly on the paper by rubbing-in or stroking one color over another. There is also a third way to mix color: by applying it in small dots in a pointillistic manner so the pigments mix visually. This technique can be seen on pages 120 and 121, where dots of apparently unrelated color near the flautist's right eye are less obvious as single pastel marks from a distance, but their overall effect is apparent. I find that generally the older the face, the sharper the changes in tone and color are needed in order to accentuate the effect of pigmented, aging flesh.

Handling Pastel
Lost-and-found technique

When trying to capture character in pastel, it is as essential to slightly exaggerate color, tone, or texture as it is to play down features that are not important in the study. One of the best ways to reduce the strength of a harsh line or area of tone is by painting it in varying degrees of pressure and width or by breaking up its edge by dragging its tone and color into adjacent areas. This is known as the "lost-and-found" technique. You will find that much effective pastel work is achieved by subtle insinuation rather than by direct statement. For instance, the outline of an arm or leg need not have a clearly.defined edge from one end to the other to appear continuous. Our minds automatically supply the missing information.

In the early stages of a study, I don't worry about the weight of a line that describes an outline or a profile—fixing the correct proportions is far more important. However, once the basic proportions are established, the overall tonal relationships laid-in, and the basic color key is decided, I begin the slow, studious process of evaluating texture, blending tone or color, and overlaying finer details in pastel. While I'm doing this, I check constantly on the strength of focal areas within a painting. I ask myself: Are some key parts too weak or over-complicated statements? Are other supposedly quiet areas too dominant? Where a harsh edge is produced by an abrupt value or color change, I drag tone or color from one area into another, making many soft strokes with the side of my little finger to control the blending. Such rubbing-in produces a softer effect not only by mixing tone or color, but also by reducing the texture of the area by forcing smudged pastel into the pitted surface of the paper.

I used the lost-and-found technique in this painting. Wherever a sharp edge was required, I employed a sharp value change. This is particularly noticeable where her profile is silhouetted against the white background and where her black cap meets the light gray background. On the other hand, where the edge of her left arm meets her cheek, I reduced the contrast by rubbing-in the edge.

Had I painted the leading edge of both thighs exactly as I saw them, it would have produced too harsh a contrast for the impression I desired. So I temporarily "lost" the leading edges by rubbing-in the pastel and destroying their shape. This produced areas of soft focus that immediately became subservient to the clearly defined face, sash, and hands—where I wanted the focus of the painting to be.

I also used the lost and found technique below the elbow of her right arm and on the front edge of her right ankle so that it is hard to tell exactly where her arm and leg meet the background.

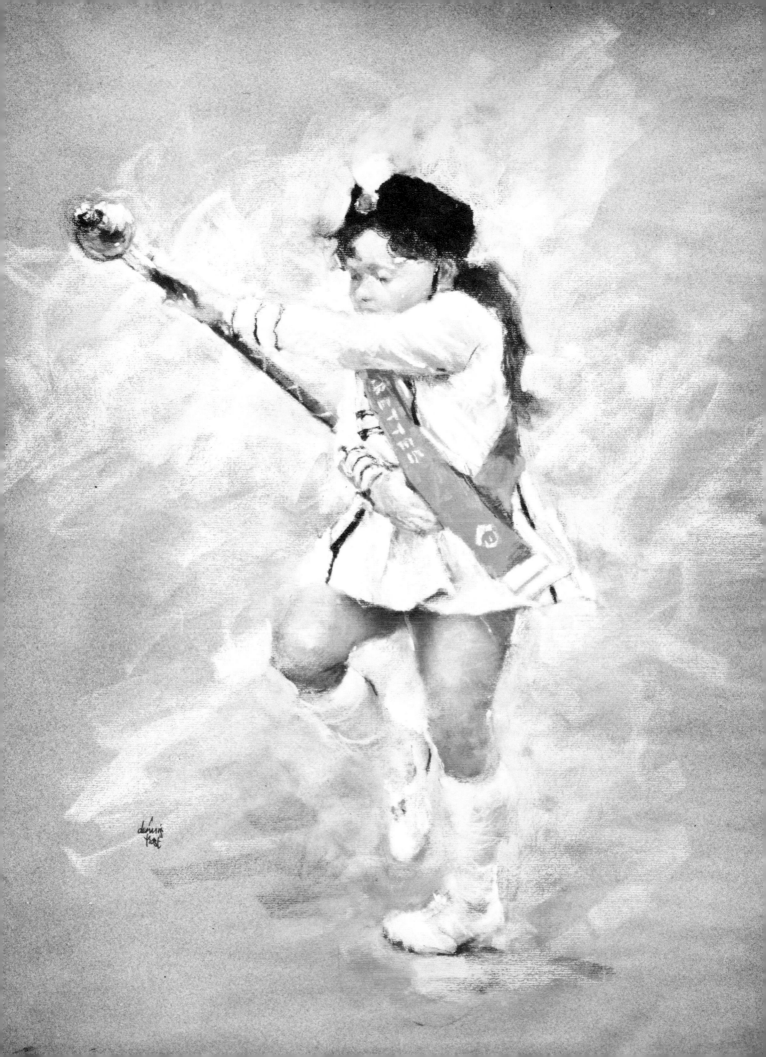

Drawing Figures

Although portraits do not necessarily include drawing the entire figure, it is essential to practice drawing figures regularly, especially in preparation for commission work.

On the following pages there are a few life-class sketches in pastel or charcoal that were made quite quickly, in about ten to twenty minutes. When you are faced with a model who poses for no more than twenty minutes at a time, it is essential to work fast, drawing the basic shapes and concentrating on reassessing them, rather than developing tonal or feature details. This discipline has great advantages in that it forces you to decide the basic gesture quickly. Although you may run the risk of making a mistake, the quick pose usually produces a liveliness and spontaneity often lacking in a more labored study.

A good life class starts with a number of short poses to encourage an adventurous approach and act as a warm-up for the longer, more studied pose at the end of the session.

Negative shapes

Creating an accurate map or outline of a subject is often complicated by the interest and detail contained within it that may distract the eye and cause it to stray from its task of relating shapes and measurements. To minimize the problem, try to see the "positive" shape of the subject as a negative shape—that is, look at the shape of the background surrounding the object. The negative shape will provide you with a very useful cross reference for getting an accurate positive shape.

This picture of a golfer in full swing is partnered with an illustration of a background, or negative shape, of the same subject.

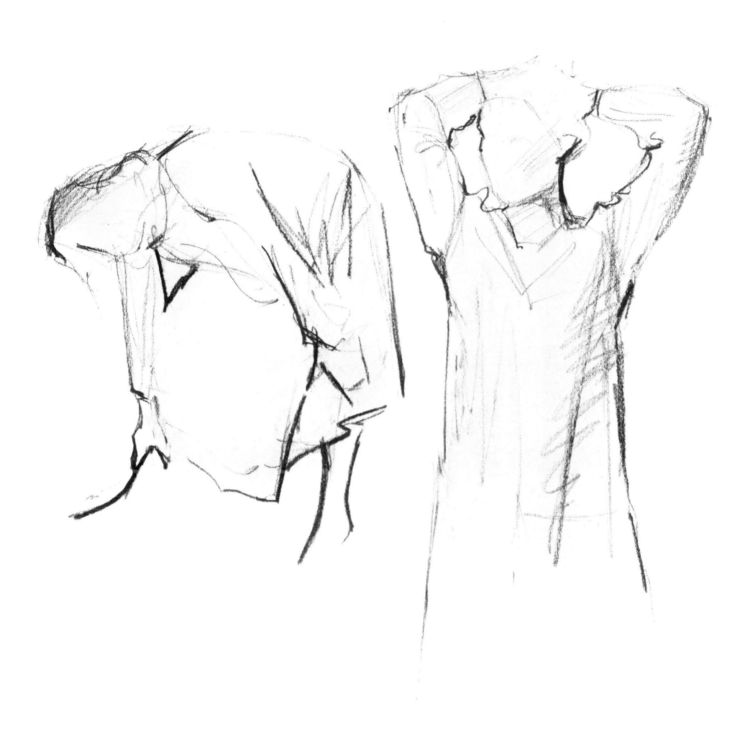

These two charcoal drawings were made in about ten minutes. These were difficult poses for the model to hold, so I had to work quickly. I decided to strive for the basic shape and ignore any details of form or value. Interesting shapes were redefined afterward.

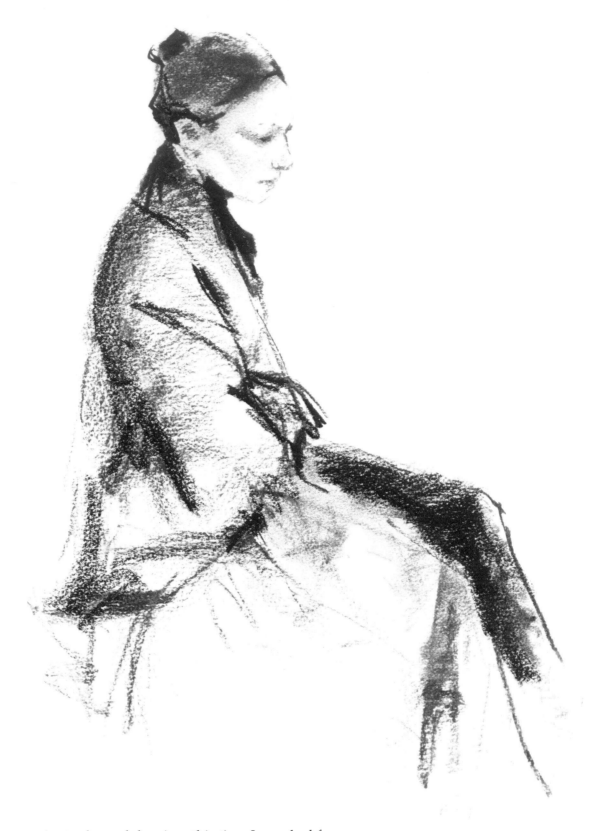

In this twenty-minute charcoal drawing, this time I searched for an expression in the figure or posture rather than the face. I went over folds in the clothes with a deep black to create greater tonal variety and provide sharp contrasting angles to the smooth soft face.

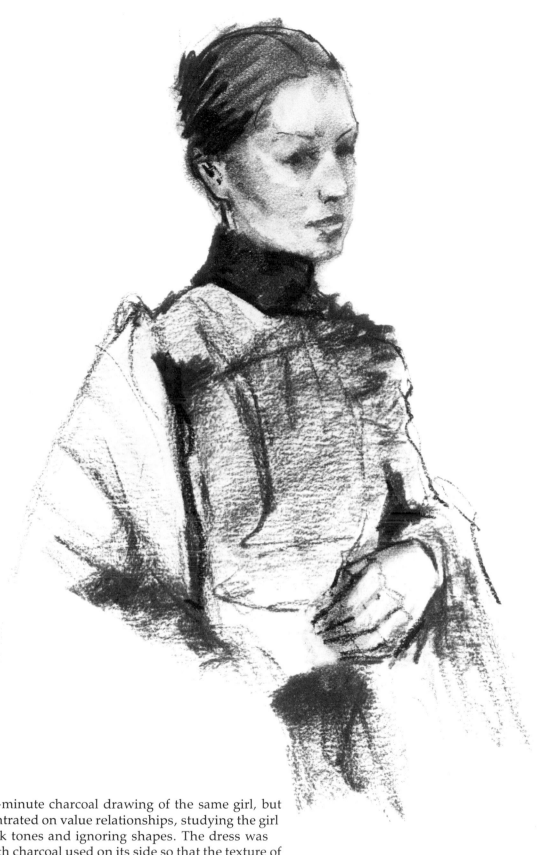

This is a twenty-minute charcoal drawing of the same girl, but this time I concentrated on value relationships, studying the girl for light and dark tones and ignoring shapes. The dress was drawn lightly with charcoal used on its side so that the texture of the paper showed through strongly. To give a softer surface to her face, I used the charcoal with restraint and smudged some of the strokes gently so that the range of values of her face was quite close. As you can see, there are no near-blacks or near-whites.

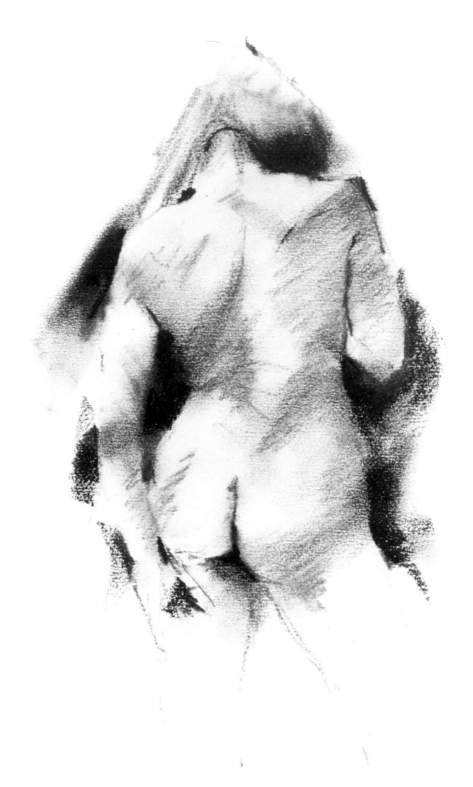

This was a fifteen-minute charcoal tonal sketch. Here my aim was to find form in the back view of a full figure. The light falling across the girl's back produced quite pronounced shadow areas and I planned to use only three values to show this: white, a light gray (smudged), and a slightly darker gray (left unblended). The contrast between these two grays is heightened because of their differing textures as well as their value: the darker gray is much more aggressive than the lighter, rubbed-in value. The hard-edged black background areas cause the white highlighted parts of the back to be even more distinct from the darker values on the figure.

(Right)
This pastel sketch on Canson Ingres paper was worked from dark to light, with the paper itself being the darkest value. The sketch has a low key; I defined the darkest areas and highlights and left the middle tones understated.

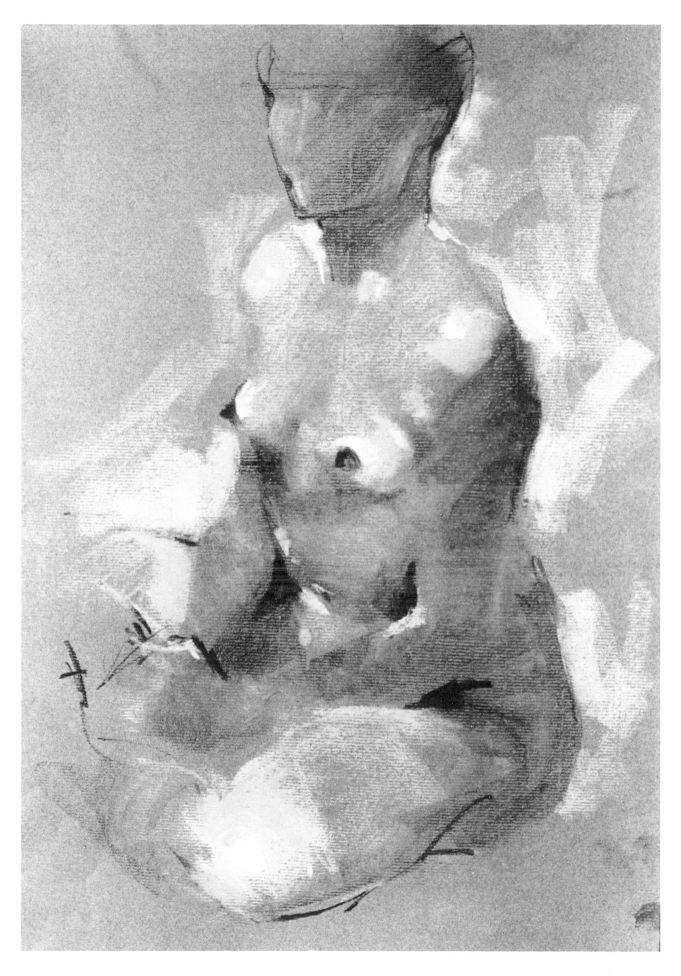

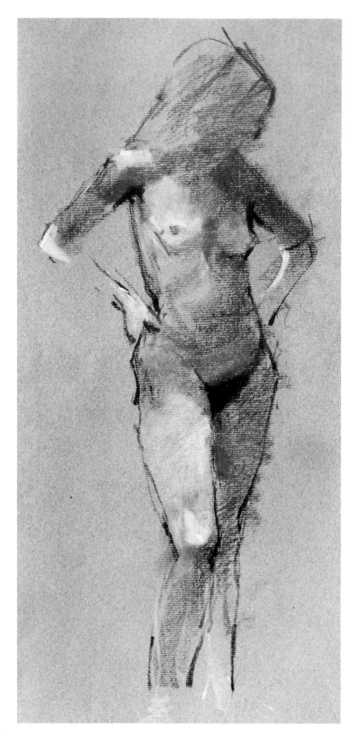

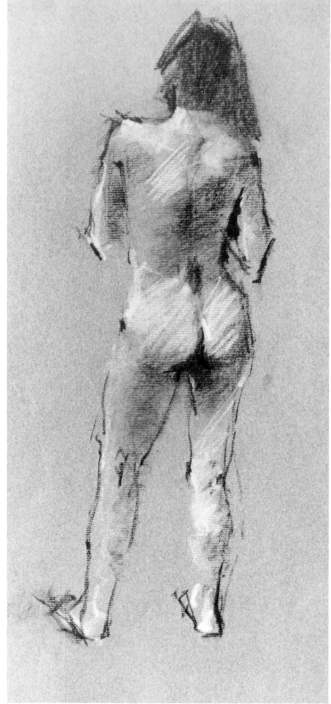

This is a quick line drawing in pastel on Canson Ingres paper. I wished to show bright light falling on her right breast and thigh, while most of her left side remained in dark shadow, so I deliberately understated her head and finally reinforced the light tones with firm pastel strokes.

In this drawing I used a similar approach to the preceeding one, but this time I established the pose by indicating points of reference rather than through strong lines. Reference points can be dots or short lines; their purpose is to establish the pose as quickly as possible. The eight reference points I used here were: (1) top of left shoulder, (2) a mark on the sloping right shoulder, (3) a point at the left hip, (4) a mark on the right hip to show its elevation to the left hip, (5) a line showing the position of the left elbow, (6) a line from the upper right arm down to the point of the elbow, (7) a point at the left armpit, and (8) points at knee and heel positions.

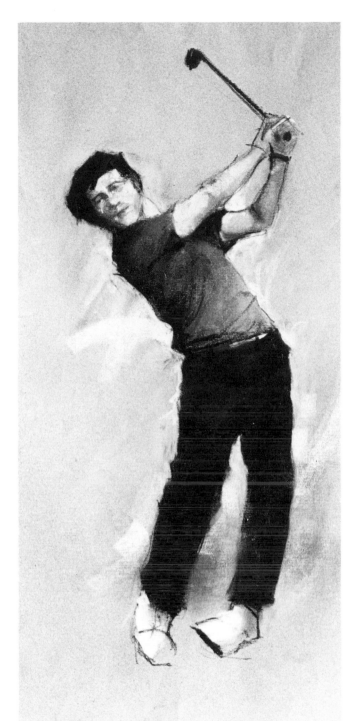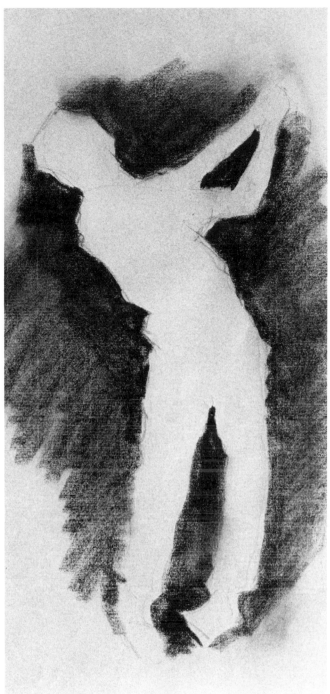

This sketch of a golfer in full swing (left) is a positive shape. It is coupled with an illustration of a background—a negative shape—of the same subject (right). The negative shape provides a useful cross reference for getting the positive shape accurate.

Proportioning the Head

After years of working with pastel, I have come to the conclusion that painting portraits really means making a series of diminishing corrections to an overall original statement (or "map") of the head and features. Once the position of the head is decided, you must work out its exact shape and proportion on the paper, bearing in mind that it will almost inevitably need to be altered during the course of the painting.

It is difficult for a painter to measure the head with a ruler or caliper, as a sculptor does. I have therefore adopted a mental yardstick and measure all features against it—usually the width of the subject's eye. As I start to define the eyes, nose, and mouth, I adjust the map of the head accordingly. From then on, I am continually measuring and calculating the features in relation to each other until the individual shapes form together to produce that elusive likeness.

The following demonstration, based on the classically proportioned *Bust of Brutus* by Michelangelo, shows how I proportion the head. I have used Canson Ingres paper and black Conté crayon with a little white pastel in the final stage.

Stage 1
My first impression of this head is that it is not quite as wide as it is long. If an imaginary square is laid around the head, with the top and side lines touching the hair, the base of the square passes just below the lower lip. I have marked the square sides "A" in the drawing, and have drawn a tentative center line and a horizontal eye line.

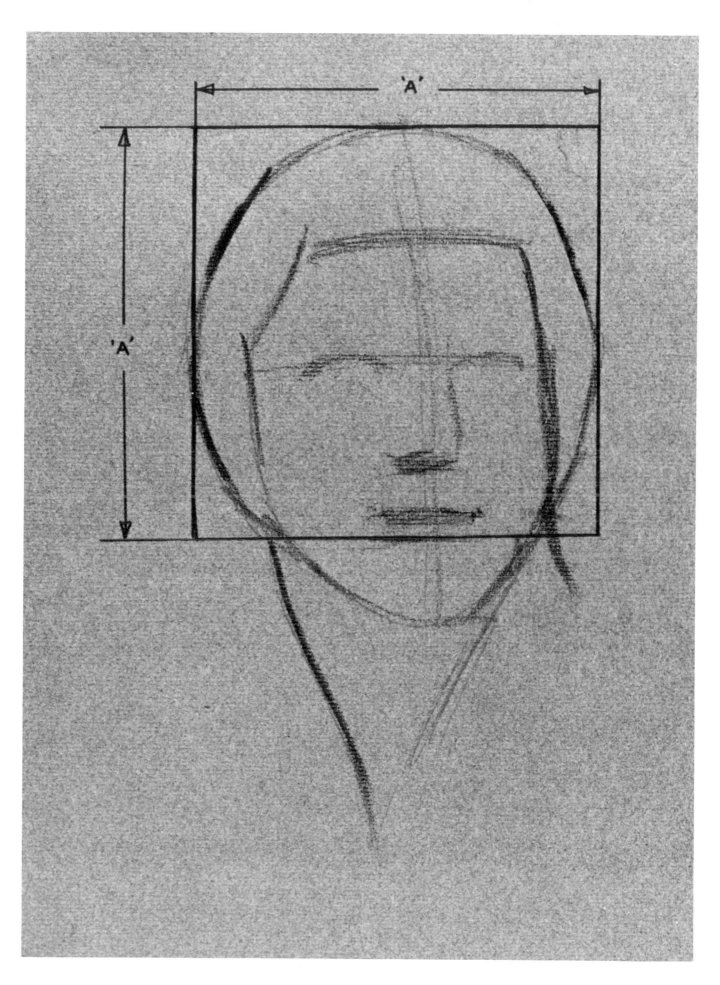

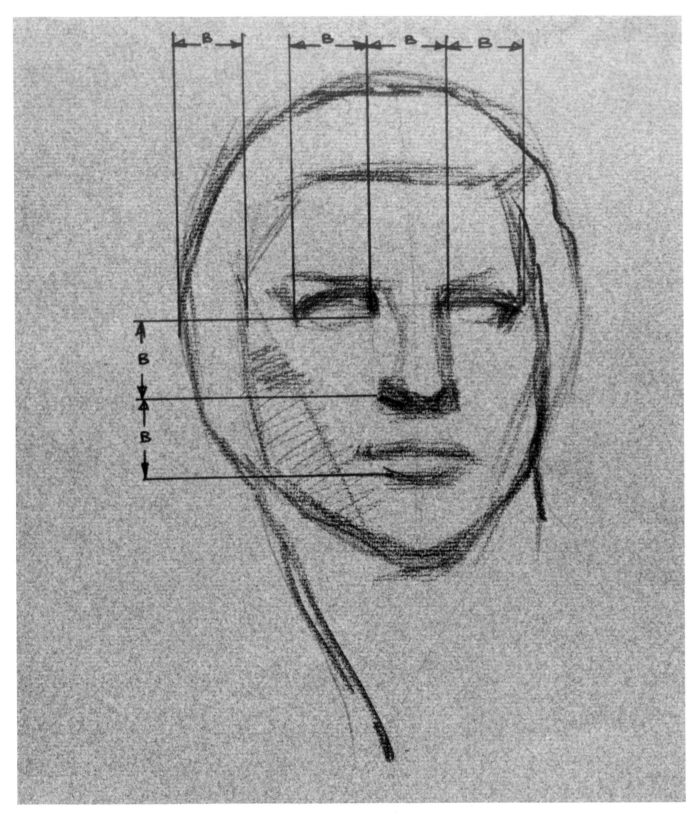

Stage 2
I have marked the length of the eye "B," and have used this module to relate other similar distances between features. Not every length marked "B" is exactly the same, but they are all similar enough for the drawing at this stage. Each of these measurements will be revalued and adjusted later.

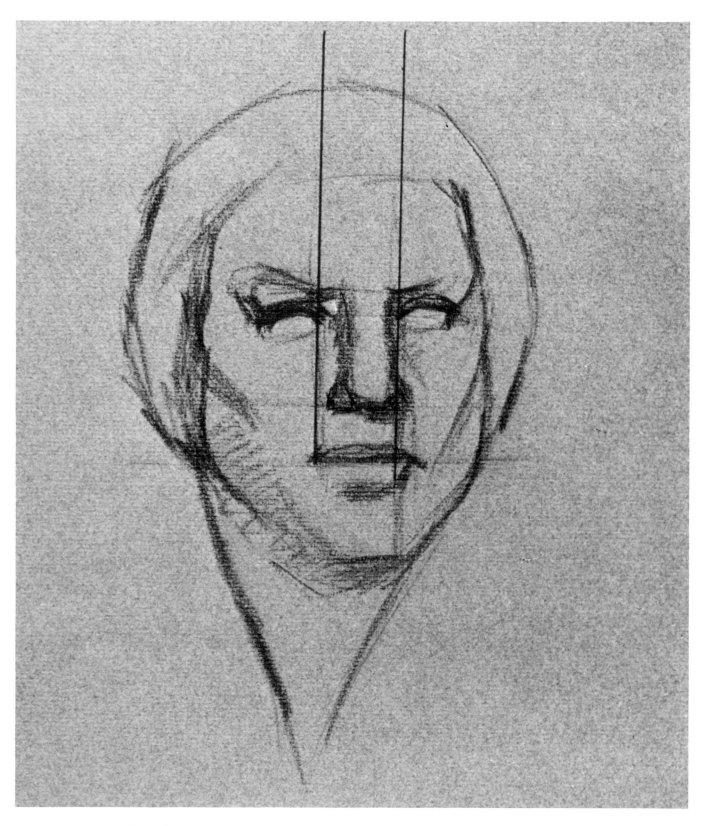

Stage 3
This is the same as Stage 2, but all the measuring marks have been removed and instead I have put in two plumb lines that pass through the inside corner of each eye. Their function is to determine the vertical alignment of features in relation to each other. These lines can be used anywhere on the head to check out the relative width of features. The line on the right passes inside the edges of the nostril and mouth, not exactly at the corner of each.

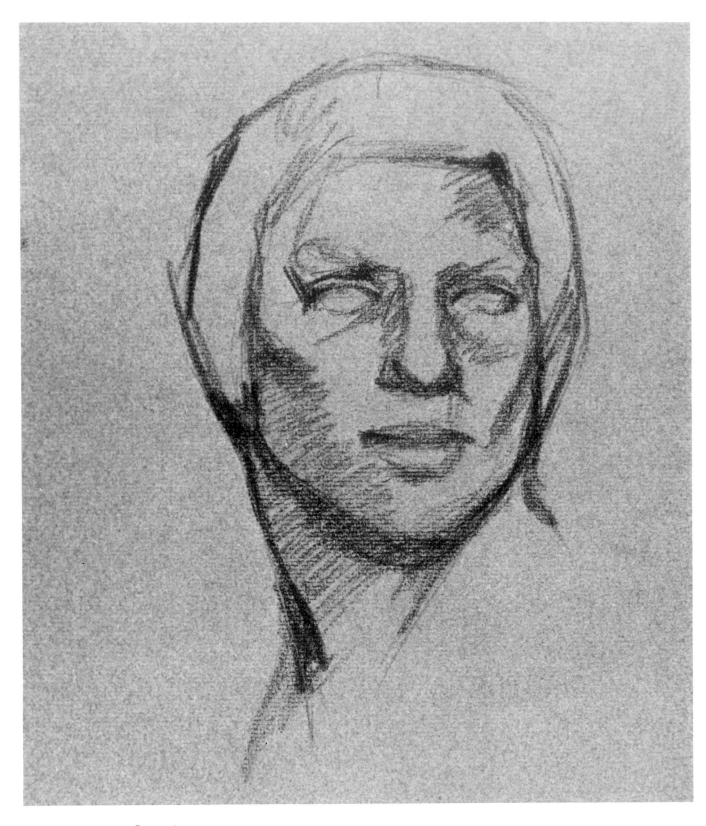

Stage 4
Once the features have been correctly proportioned, I start to define the areas of dark tone. This gives the head the illusion of being a solid object. Although these dark areas appear to have been sketched in quickly, I am careful to make the shape of each area accurate so that a likeness is apparent. I have also strengthened the outline of the overall shape.

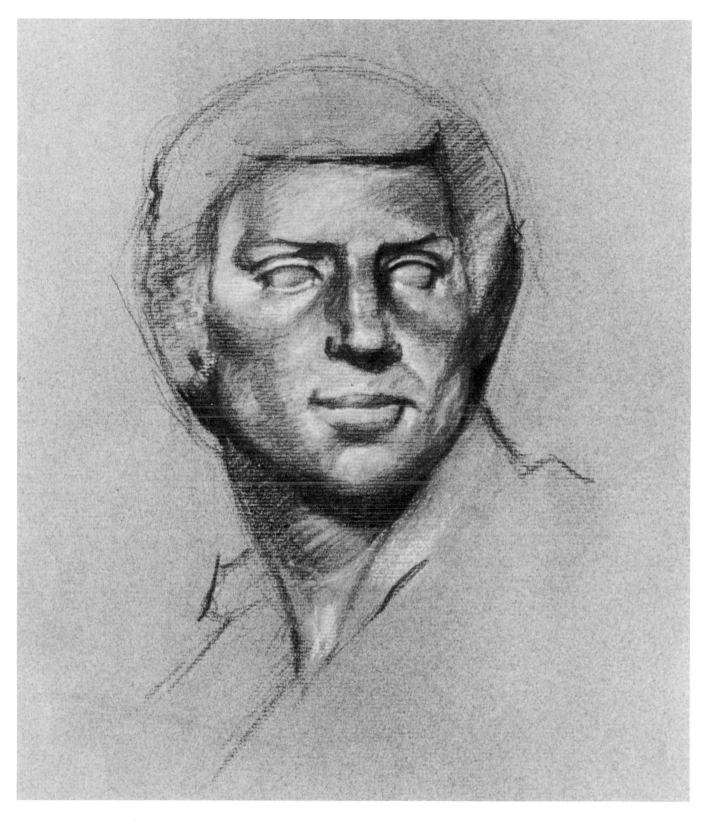

Stage 5
In the final stage I juggle with values, working from dark to light. I make many tiny corrections to the edges of features, redefining their exact position and tonal weight. The shadows of the facial muscles have been reinforced with white pastel to highlight and build the form, and I have used my little finger to rub-in where a gradual change of value or plane was necessary.

Proportioning the Stance

Getting the correct stance is more difficult than drawing the head, but the same techniques are involved. The easiest way to establish the correct proportions is to measure the body in head-sized modules. Then, to align parts of the body, I use plumb lines as before, but I run them from head to foot and note which parts of the anatomy fall along their line. This is a tedious process, but one well worth doing because it is extremely important to have the figure stand in a credible position.

I drop the first plumb line from the furthest point on the left of the head, then work across to the right. The head of a relaxed standing figure is always positioned directly over the main supporting foot, or between both feet if the person is standing with the weight distributed evenly on both feet.

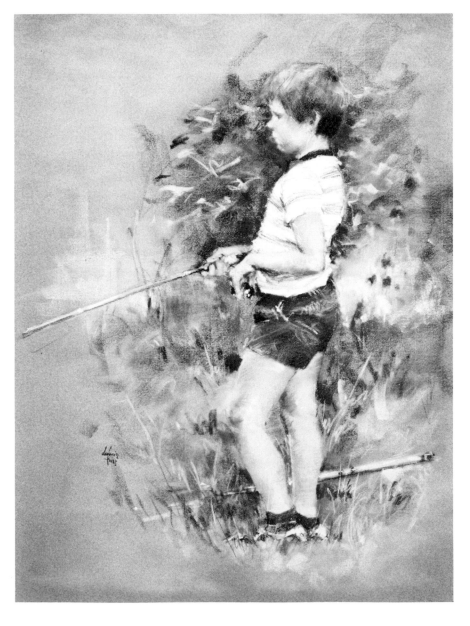

Here, a plumb line from the boy's ear drops directly to the center of the foot of the supporting leg and the boy's head is set slightly back from the figure, creating a slumped stance. Note also that the boy's head is slightly larger in proportion to the rest of his body than an adult's head would be. The difference between head and body size is even more pronounced in a small child.

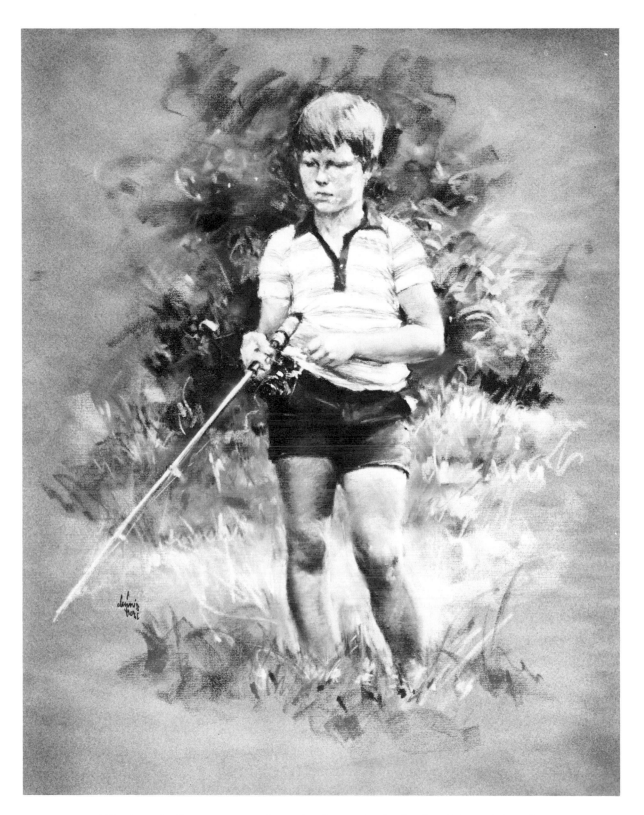

This is a similar pose seen from the front. Again the head is positioned directly over the supporting right foot. The right hip juts out a little, but the leg swings back inward to place the weight over the center of gravity. The arms and shoulders are slouched in this comfortable stance, but since the right knee is locked, this position can be held for a long time.

When painting this boy, I proportioned the facial features after I had proportioned the figure. One interesting point is that the curved shape of the figure is compensated for by the lighting, which is brighter on the left leg, arm, and side of the head.

Bad Habits

Once you have picked up a bad painting habit, it is very difficult to lose it. In my own and students' portraits, ranging from quick studies in charcoal or Conté crayon to highly finished pastel or oil paintings, I see the same artists making the same mistakes over and over again. It is often difficult to convince a painter that a fault exists, although it may be most apparent to others, but blind spots are not unusual and most artists will frankly admit (at least to their best friend) that they have an "Achilles heel." My own blind spot is the area directly below the nose, and between the nose and top lip, which I regularly draw too long. I still cannot trust myself to proportion it right every time, so I have a special ritual that I go through once the head is drawn and the features are positioned. It involves carefully checking the areas that give me the most frequent problems: top lip, size of the eyes, and the width of the space between the eyes. I even have a card pinned to the top of my easel with the initials of these quicksand areas in large letters to remind me: TL BE WBE ("top lip, big eyes, and width between eyes"). It sounds ridiculous, but it has saved me many hours of reworking and steered many of my paintings nearer to the desired interpretation.

Interpreting values

The most common pitfall is in the accurate rendering of values. Although you may have drawn a portrait faultlessly and have achieved a good likeness, if the darks and lights have been assessed poorly, the final result can be extremely disappointing. An example of this kind of error is a typical interpretation of the whites of the eyes: The whites of the eyes are not white; they are closer to a medium-light grayed flesh tone. If they are painted white, the result will be a staring hypnotic face you might see in a horror film!

It is quite easy to avoid making this mistake. The secret is to study the darkest and lightest tones within a subject during an early stage of drawing and then state them simply before attempting to indicate any of the intermediate tones. Do this by looking at the subject through narrowed eyes. This blurs the image and diffuses the focus, which in turn reduces the tones and shapes to simple basics.

Just as you should be constantly checking the facial proportions (see pages 30 and 31), so you should also be relating shape to shape and tone to tone through all stages of a painting. This may become more difficult as more line, tone, and color is applied to the paper, but it is much better to stop and untangle the relationships between these qualities of pastel early rather than to continue in the hope that they will turn out all right in the end. As the portrait develops and the proportions and shapes are established with increasing

confidence, the more subtle tones so necessary to the finer qualities of the study can be added.

The correct interpretation of values is the most important factor in creating a successful painting. If the values are right, the color will be exciting and relatively trouble-free.

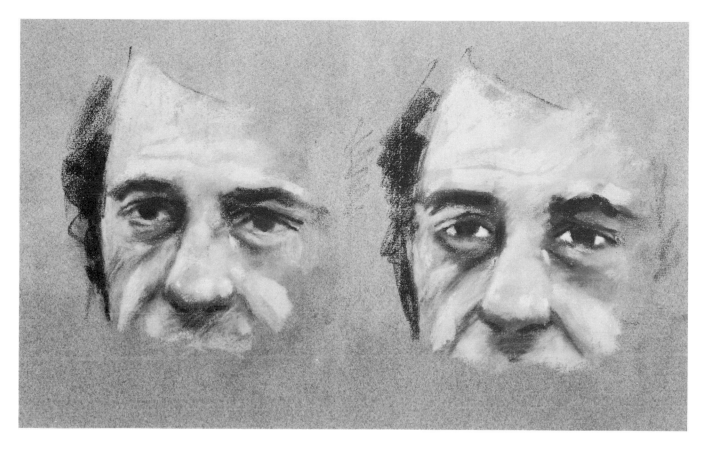

White highlights have been included in the features of both faces. However, the eyes on the right contain the lightest tones in the face because they were assumed to be white. But the eyes in the face on the left are in fact more realistic because they are a medium-light value.

Eyes

Painting the eyes is usually a high point in making a portrait, as they are often the focal center of the work and give much information about the character and mood of the subject. When trying to obtain a true likeness, it is essential to catch the exact shape of the eyes—their value and color are less important.

Here are some general rules that apply to eyes. Memorize them and check them against the portraits in this book: Young people's eyes are usually clear, with sharply defined changes in shape and tone. The whites tend to be slightly blue, especially in babies, and the flesh is a close, neat fit around the eye. The eye is usually larger in proportion to the rest of the face in a child than it is in an adult. The skin around a young person's eyes is smooth and clear and tonal changes graduate gently from the eyelids out to the eyebrows, nose, and cheeks. In old age, however, the eyelids tend to become loose and creased with tiny folds of skin, and the rims may become red. The whites of the eyes are dimmed and discolored, ranging from yellows through to reds caused by small bloodshot veins. The iris may become paler and the outer ring of the iris may often grow darker, resulting in a three-stage color effect.

Eye shapes

A simple way to see how the eye changes shape as the head turns is to make a model eye, like the one shown here, from an orange with a thick peel, a sharp knife, and an old ballpoint pen. Remove a segment of peel, cutting carefully down as far as the pith. Make sure the segment is symmetrical, then insert the ballpoint pen into the base of the orange as a holder. The cut-away segment is approximately eye-shaped and will change profile as the orange is turned through 90 degrees. Tilt the orange forward and backward to see how the eye alters when seen from above and below, respectively.

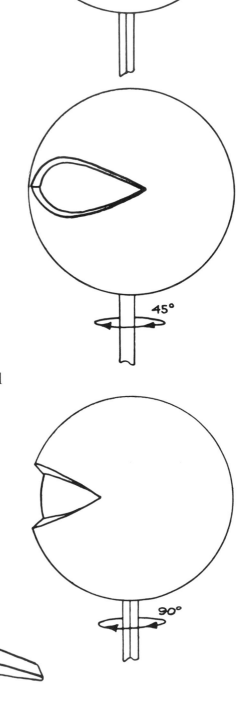

I have made a more permanent teaching aid to show this by cutting an eye-shaped segment out of a tennis ball and then inserting a slightly smaller wooden ball inside to represent the eyeball. I painted an iris and pupil on to the exposed part of the wooden ball to show how these features also alter during the turning of the head. But this model is only intended to explain the basic principle. Since eyes vary in shape from person to person, it is essential to study and draw them often to try to capture the subtleties that determine the individuality of your subject.

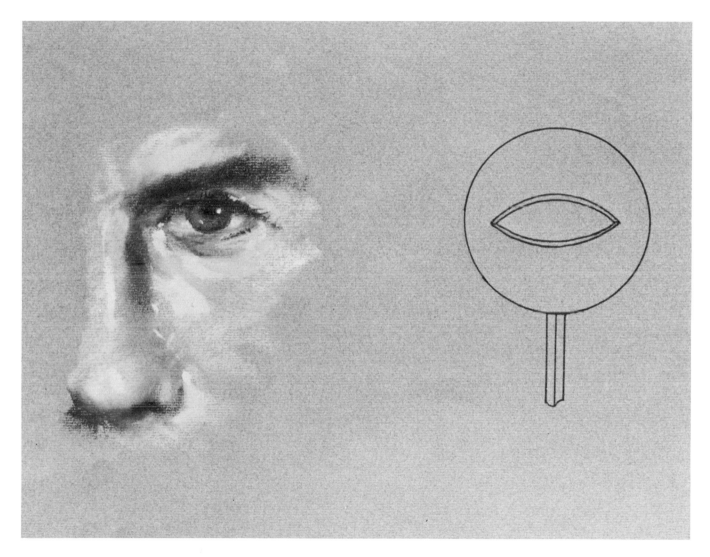

Viewed straight-on, this eye is almost exactly symmetrical. Since the face belongs to a middle-aged person, the eyelids and skin are slightly wrinkled and the eyebrow casts a dark shadow over most of the upper eyelid.

First, the shape of the eye was outlined in bistre Conté crayon. Then the iris was added with blue-gray 6 (727.5), and the white of the eye with indigo 7 (506.9). Next the outline of the iris and the pupil were put in with black Conté crayon and a little blue-gray 4 (727.4) touched into the lower right-hand corner of the eye. I smudged some of the flesh color from the upper eyelid into the white of the eye on the left side to show reflection and finally touched in two tiny dots of indigo 7 (506.9) as highlights.

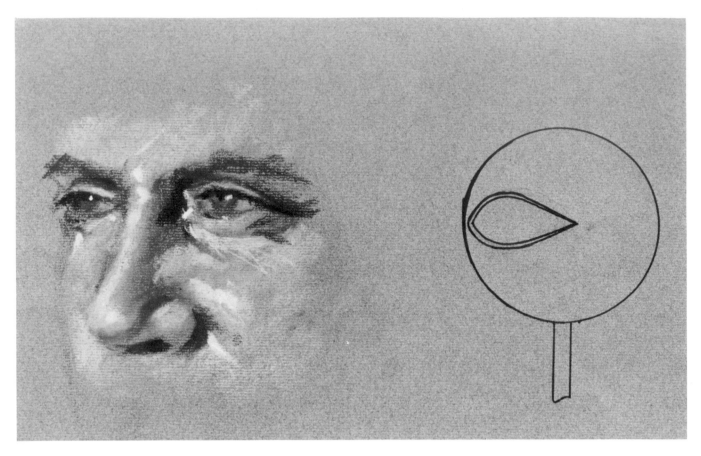

The segment cut from the orange exaggerates the shape of this eye; it appears too wide. In the pastel example, the eyelids have narrowed, revealing less of the eyeball and causing more creasing and darker shadows in the surrounding areas. The whites and iris are very close to each other in value and the black pupil is loosely stated. The upper eyelashes make a dark sweeping line, while the lower rims show few, if any eyelashes. The pouches below the eyes are created by layers of dark and light tones worked into the eyes in that order. Basically, the underlying dark tones have been rubbed-in a little and the light tones on top have been left unblended as single pastel strokes with hard edges. I have used cobalt blue 2 (512.7) and white to show these whiter areas. Although cobalt blue 2 would never appear as I have stated it in real life, its overall effect gives the correct age and feel to the skin of this person.

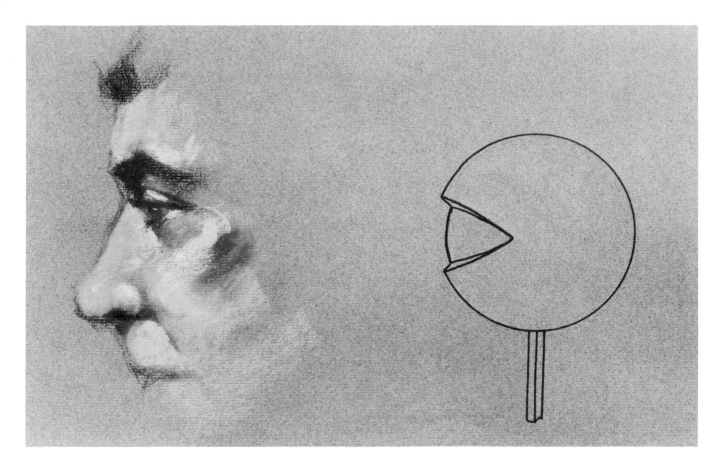

Little of the eyeball is visible in a profile. In fact, it is difficult to distinguish between the white of the eye, the iris, and the pupil; there is only a gradual change in tone. The upper eyelashes form a hard black line and the fold in the upper eyelid is clearly visible. The eyebrow in profile appears very dark. It is a single tone of pastel, left unblended to allow the tooth of the paper to show through and break up its overall strength.

The eye is set well back from the front of the face in profile. Careful use of plumb lines (see page 31) is necessary here to produce a credible arrangement of features.

Highlights

When highlights are introduced to my paintings, they are usually restricted to tiny areas of pastel. The highlight must not be dominant. Even if you are stating the very bright pinpoint of light sometimes apparent in the eye, it is easy to make it either too bright, or too large. Generally, my approach is to make it a little brighter and a little smaller than it should be. By touching the pastel highlight with my finger, I can also tone it down and make it larger.

When describing a highlight on flesh, the same technique is employed: Start off bright, then tone it down and give it form or direction with a blending action of the finger.

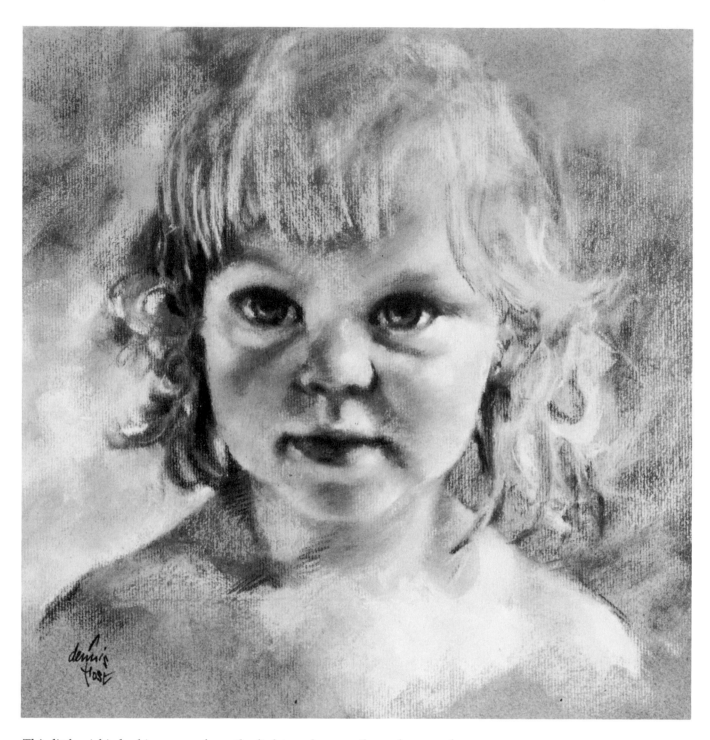

This little girl is looking away from the light, so her pupils are large and her eyes are wide open. The skin around her eyes is smooth and padded with young "puppy" fat and the tonal changes in the eye are clearly defined. The bridge of her nose is low and unformed, causing only a gradual change in tone from one eye to the other. Her eyebrows are fair and hardly noticeable.

Her expression is created by her wide-eyed innocence and relaxed mouth. To capture this mood, I rubbed-in a great deal to get gentle changes from one tone to another. I also kept the overall key high, with a minimum use of darks. Too many darks may cause a painting of a young child to look heavy and sinister.

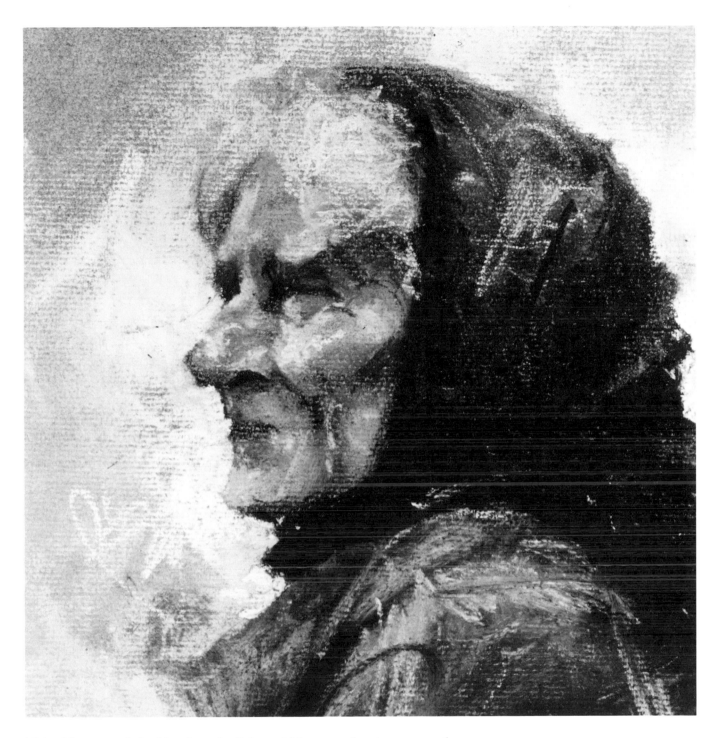

This old woman is looking into the light, which causes her to screw up her eyes against the glare. Since her eyeball is completely hidden, her eye is represented by a single smudged line. But her eyeball appears to be visible because we imagine it to be so. There is heavy shadow around her eyes and the pouch below them is clearly defined. Her weathered expression is produced by a tightly pursed mouth and small pastel marks of contrasting tone that jostle for position on her cheek and nose, below the eye. I did not rub-in at all on the lightest areas on her face so I could produce patches of tone that would give a worn and weathered look. It is interesting to note that most of the expression on the faces of this old woman and the child opposite is insinuated, rather than precisely drawn. Exaggerated color and tone, careful lighting, choice and interpretation of background, and the bare shoulders of the child as opposed to the weathered scarf on the old woman all help in creating their respective characters and surroundings.

Wrinkles, Folds, and Creases

Dark lines caused by folds in the skin are extremely important in conveying the age of a subject and describing the facial expression. These lines, a product of maturity, become more numerous with age so that the neck or areas below the eyes eventually becomes a mass of creases and folds. The most convincing way to paint them is by widening the dark center line of each crease, and then carefully 'sandwiching' the precise shape between lighter tones. If necessary, the dark line at the depth of the crease can be reinforced. Starting with the dark lines and working the lighter tones over them produces far better results than the reverse (painting the shadow and line over the lighter flesh tones), even if the line on the subject appears to be hard and isolated, without any gradual darkening of its edge.

(Top)
There is a rough rendering of rubbed-in light and dark tonal areas on the forehead on the left. The dark tones that later form the base of the crease are only broadly positioned here; stating their tone is more important than actually drawing them in at this stage.

Lighter tones have gradually been worked in on the forehead on the right, and the flesh is now much lighter. The middle values have been rubbed-in, but the final, lightest tone has been dragged across the paper and left unblended, resulting in a broken texture that allows the underlying darker tone to show through. The lines that form this frown are not deep and dark, but only reach a middle-value tone at their center.

(Bottom)
The fold of the cheek is the only line in an area of otherwise smooth skin. It contrasts sharply, in tone with the tightly drawn skin on the upper lip area, but softly fades into the other side of the cheek. This crease was painted the same way as the frown on the preceding page, but after surrounding the dark tones with light ones, the line was reinforced with a single thin stroke of dark pastel to strengthen it. The same basic flesh tone found in the painting on the left has here been allowed to show through in places, giving an underlying tone of subtle gradation.

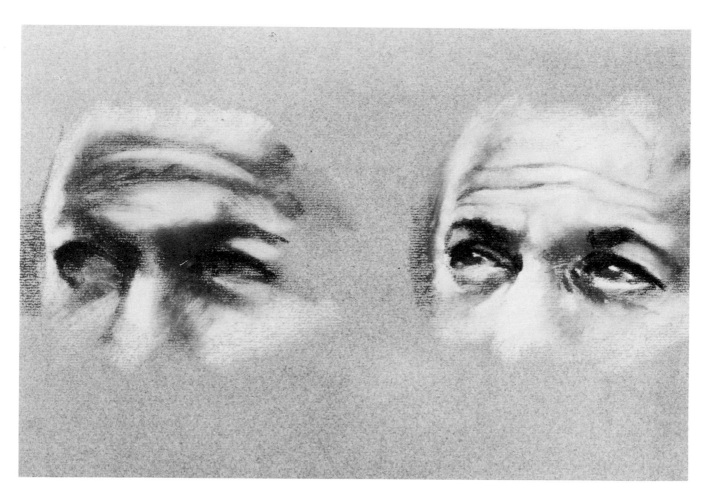

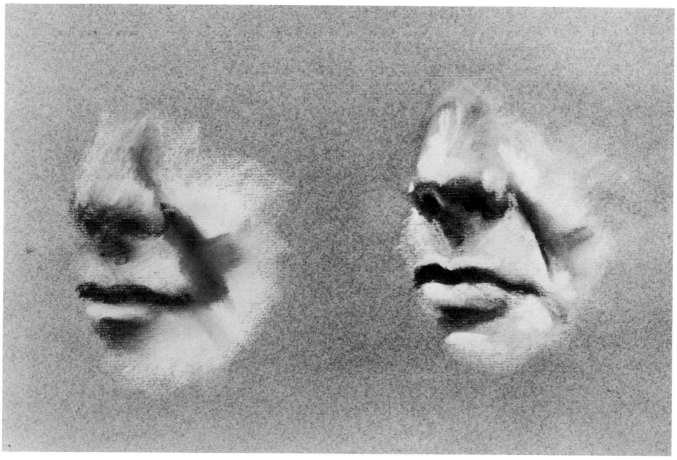

Anatomy of a Smile

A smile is exceptionally difficult to paint because, being a temporary expression, it is hard to observe it long enough to reproduce it. However, when a smile spreads across a face, certain facial movements always occur. Knowing which features change and how helps painting this expression. Therefore, the gradual movement of the features into a smile is shown on the following pages.

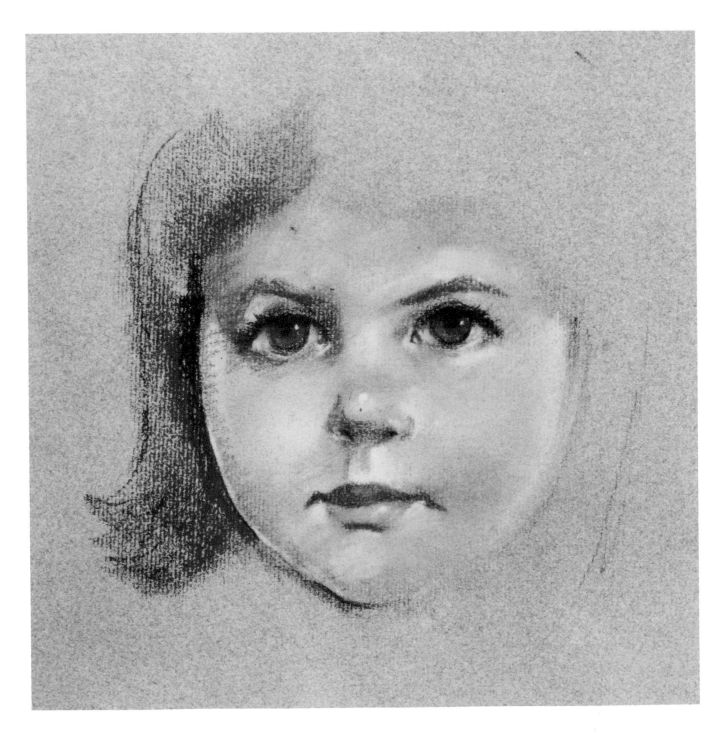

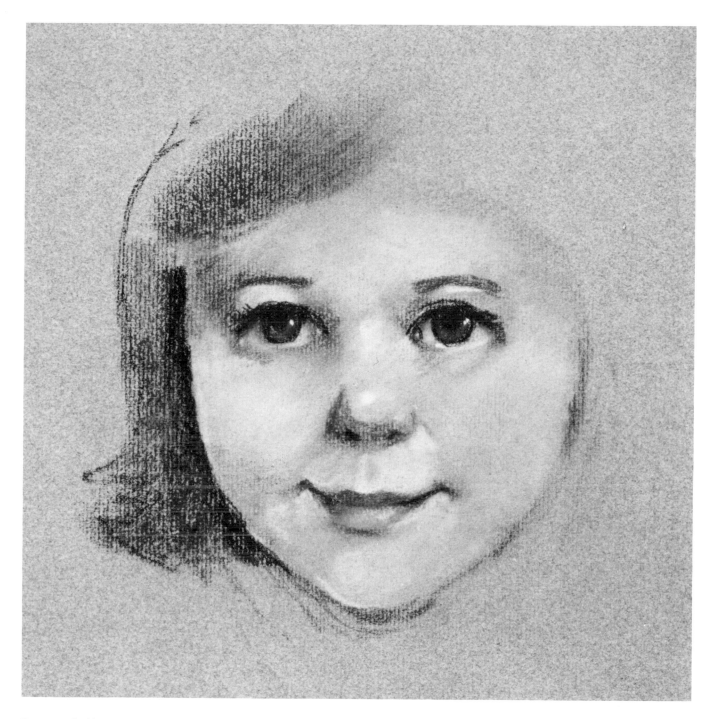

Stage 1 (left)
Here the little girl's face is completely relaxed and has no particular expression or animation. The curve of her cheeks from ears to chin is smooth, her eyes are fully open, her upper lip is in full view with a slight pout, and there is a shadow in the small vertical channel in the skin above the upper lip.

Stage 2 (above)
The first signs of a spreading smile are in her eyes and mouth. The cheeks become slightly rounded as the mouth begins to widen slowly. The shadow in the skin above the upper lip starts to disappear, and there are signs of muscles tightening under the skin at the lower sides of the mouth. The eyes start to narrow as the lower eyelid is pushed up by the muscular activity in the cheek. The eyebrows straighten a little.

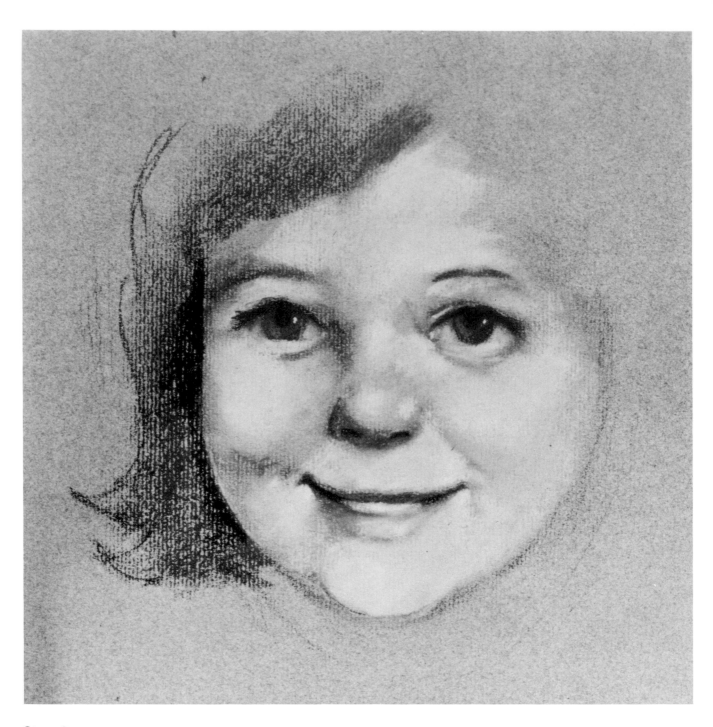

Stage 3
The overall width of the face increases and there is a swell in the curve of
the cheek. The teeth appear for the first time as the upper and lower lips
become straighter. The shadow in the skin above the upper lip
disappears, and this area reduces in height as the lip pulls up over the
teeth. A fold in the flesh appears at each side of the mouth, running to the
edge of the nostril above. The cheeks become rounded and appear as
separate muscles from the rest of the lower face. The nose becomes flatter
as the nostrils widen. The chin is more pronounced. Finally, pouches
appear under the eyes and the eyes narrow as the cheeks tighten.

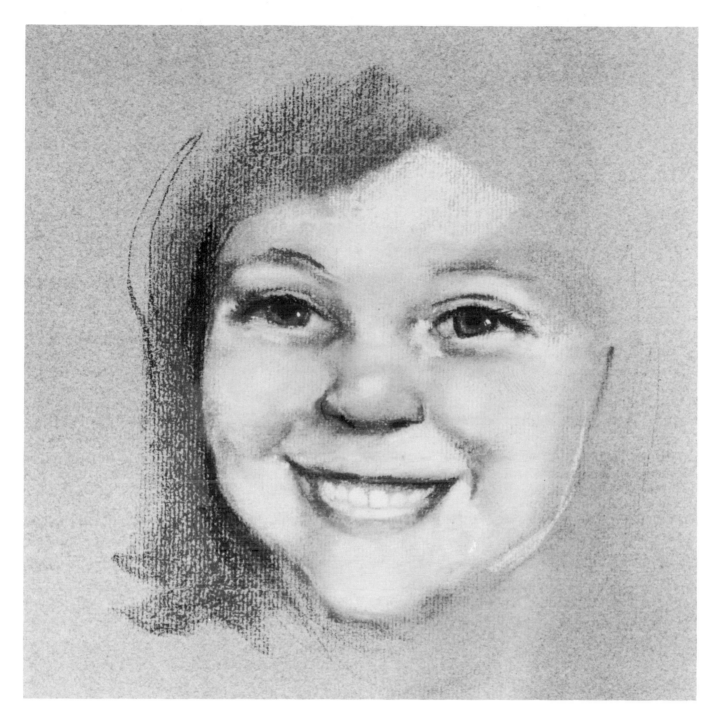

Stage 4
The face now has a broad grin. The teeth and gums are visible as the mouth is stretched wide. The lips are taut and thin and deep channels run up toward the nose from each corner of the mouth. The line of the cheek is no longer smooth and the cheeks are rounded and high. The nose is flat and wide and folds of skin are apparent below the eyes, causing the eyes to narrow much more. In some smiles, the eyes narrow to just a slit and are barely visible. Tonal changes are much more acute here than in Stage 1, where there were only shallow contours in the flesh. As you can see, the overall shape of the face has altered radically in the course of the spreading smile.

Mouths

An artist once said, "A portrait is a painting of a person with something wrong with the mouth." Most portrait artists would agree that the mouth is the most difficult feature to paint with accuracy because it is the most mobile of the features and is capable of so many different poses, as you can see in the smile sequence on pages 46 to 49. Unfortunately, a smiling or laughing portrait is often requested and painting it fills me with dread. I know from experience that the extent of the smile will vary by the moment, with teeth appearing and disappearing and after a prolonged period, if maintained that long, this happy expression will turn into a ghastly grimace due to the subject's discomfort. But since a pleasant mood is contagious and reflects in the mood of the painting, I try to encourage the subject to hold a pleasant half-smile for the duration of the sitting.

It is difficult to make a study of mouths, but a few general rules do apply: Older people usually have thinner lips than the young. A toothless mouth causes the cheeks to collapse, with the subsequent folding and creasing of the lips. Children sometimes hold their mouths in an asymmetrical position, giving their lips an unbalanced shape. In a sad expression, the mouth tends to turn down more than usual at the corners, but on a happy face, the mouth becomes straight or upturned.

(Top)
The lips in the upper right study are pale and thin. They can be painted by using the same technique as the one described for shadows and creases (pages 44 and 45).

The mouth in the center shows no lips. The line separating the lips is therefore no more important in shape or tone than any of the other folds of flesh on the face.

The mouth in the upper left study is lacking teeth, with the result that the usually pronounced upper lip has completely collapsed, causing heavy creasing at the corners. Here the line of the mouth is simply a dark crevice between chin and nose. It gives the impression of meanness purely because it folds down at the corners.

(Bottom)
Black people often have fuller lips than whites. The sneer on the mouth on the right was produced by painting the flared nostrils and by curling the outer edges of the lips. However, even though the flesh colors are darker, the value relationships of the skin on the chin, cheeks, and nose of a black person are the same as in a white person's face.

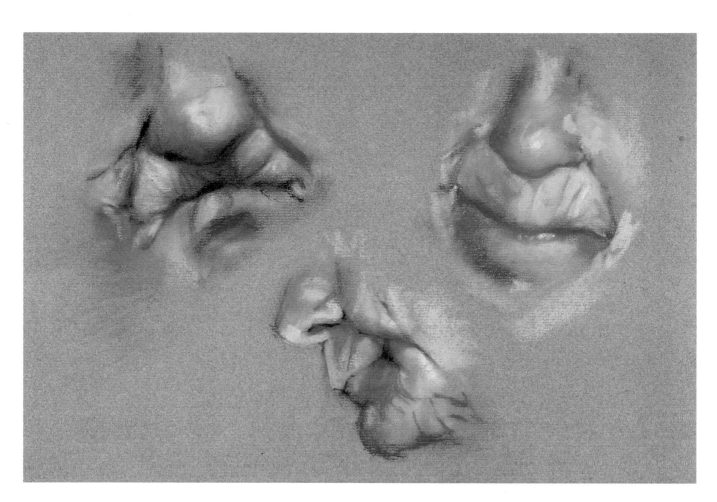

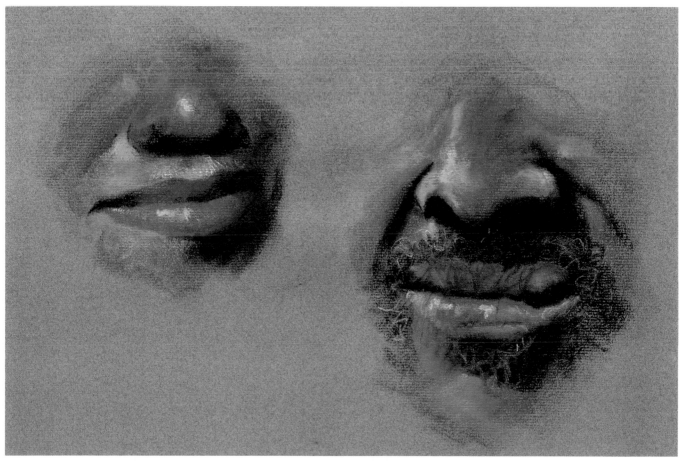

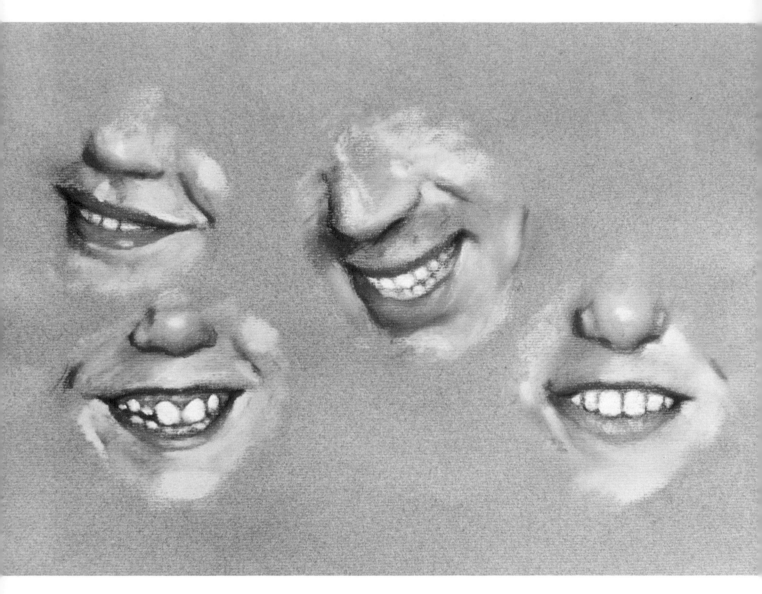

In the course of a smile or laugh, the lips reveal the tips of the teeth first, and as the expression becomes more mirthful, more teeth and gums are exposed. The expressions on these mouths vary, but the painting technique is similar for each. First, the outer edge of the lips is put in with bistre Conté crayon, then sanguine Conté crayon (a lighter tone) is applied to the flesh above and below the lips, followed by an overpainting of madder brown 0 (339.9). A little rubbing-in around these areas produces a gentle tonal graduation. Poppy red 6 (318.7) is used for the lips and silver white (100.5) is used to indicate the teeth. It is essential to first outline the teeth with a dark tone, such as a black Conté crayon and then apply madder brown 0 (339.9) for the highlights on the edges of the lips and to create the lightest tones in the surrounding flesh.

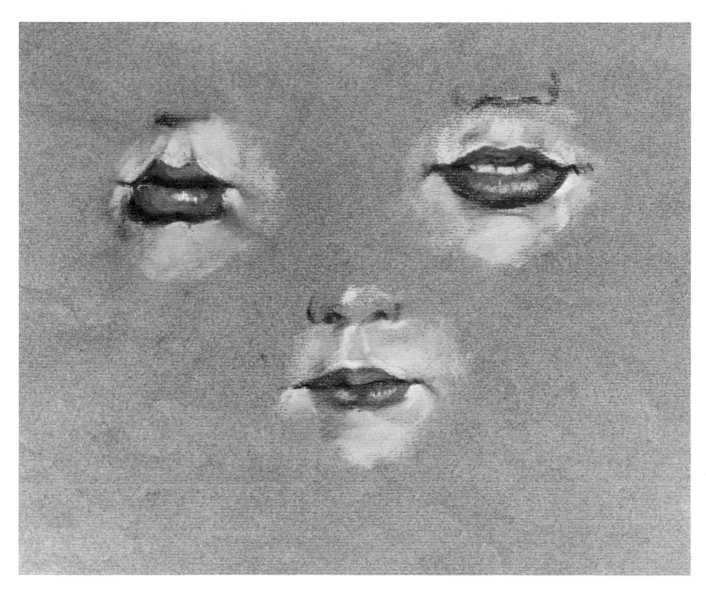

Children's mouths are painted the same way as smiling and laughing mouths. In general, their flesh is very smooth, their lips are red and full, and their teeth show less than those of an adult. When a child is grumpy, the lower lip will pout, as in the study on the upper left.

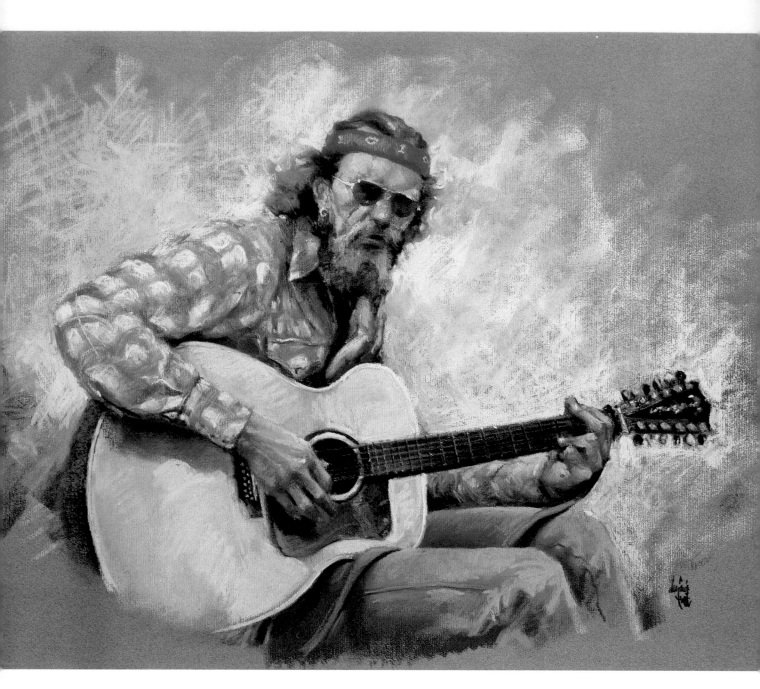

There is something soulful about this guitarist's face. Even though his eyes are hidden behind sunglasses and it is not quite possible to make out his mood, the angle of his mouth reveals the nature of his song. His lower lip is thick, dark in tone, and slightly pouted, enhancing the serious nature of his musical message. Although his upper lip is completely hidden by his moustache, it is still possible to read his expression with ease.

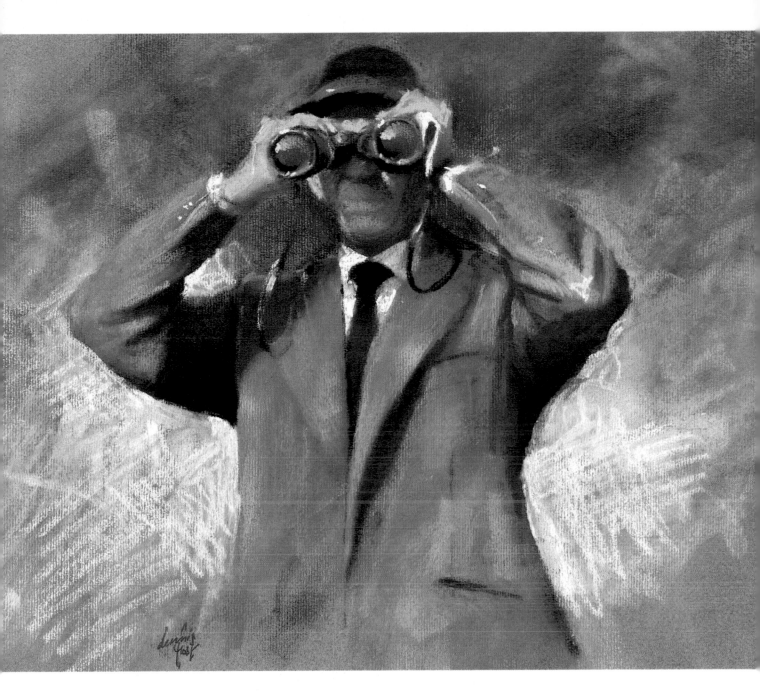

This man looks sinister. His clothes and complexion lack cheerful color and the vigorous application of bright white behind him—a background that suggests outdoors but also serves to dramatize the figure—produces a harsh tonal change that creates an awkward visual jolt. The binoculars conceal the eyes and produce a gaping stare, that causes the mouth, as in the painting on the opposite page, to be the feature that provides the greatest clue to his character. His lips are terse and are almost the same color as the rest of the face. The dark tones that have been worked in across his jaw, together with the flat nose and the heavy creases that run from the nose to the corners of the mouth all combine to create a detached unfriendly expression.

Noses

Noses are quite easy to portray in a profile. But when painted from the front, they present problems because they have no particular shape and you must rely almost entirely on the subtle interplay of tone to describe them. The shape of a child's nose is even less pronounced than that of an adult, and since there is also less opportunity to use contrasting colors to portray the skin on a young face than on an old one, the values you choose must be extremely accurate.

When setting up a composition and arranging the lighting, take special notice of the definition of the nose as well as the most typical and attractive aspect of the subject. When making a full-faced portrait, where the nose is foreshortened and the profile shape is completely disguised, arrange the lighting to create shadows that will show the shape of the nose and other outstanding features to their best advantage. This way, you can retain the characteristic qualities that help individualize the portrait.

(Top)
To draw a nose, you must first study the basic shapes. From a frontal position, the strongest shape is the ball of the nose, the wings of the nostrils, then the bridge, and finally the shallow area on either side of the bridge. The direction of the lighting also defines the shapes. For instance, the nose on the upper right was lit from above, which resulted in an area of light tone that extends down the bridge and recedes into a small trough of darker tone just above the ball of the nose. This shows that the line of the nose is not straight. The cast shadow also defines the shape of the nose. To paint the nose, decide where the lightest and darkest values lie, then match other areas of similar value to one another. Here the cast shadow is the darkest tone, followed by the area at the side of the nose, then the bridge. Variations in contour also affect your treatment of the pastel. For example, along the sides of the bridge where there is a gradual change of contour, I rubbed-in the pastel, but where the cheek meets the wing of the nose, I left the pastel unblended to show a sharper change of plane.

(Bottom)
I have painted a large chunky nose in order to exaggerate its construction and tonal planes. As in the examples above, I have isolated the basic geometrical shapes, but here the frontal lighting has thrown the side area into shade, producing a range of gradual and sharp value changes. The darkest areas are the nostril openings, the corners of the eye, and the pocket between the nostril and ball of the nose, which shows the flare of the nostril strongly. Note that the fold of skin in the corner of the eye produces a sharp value change, while the gradation from cheek to nostril is softer and more gradual. Also, the area between bridge and nostril contains little pastel in contrast to the heavy application of pastel on the front edge of the nostril and the ball of the nose.

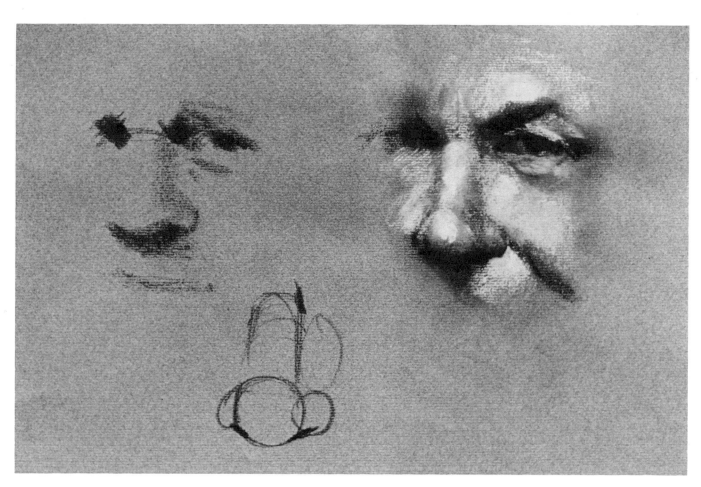

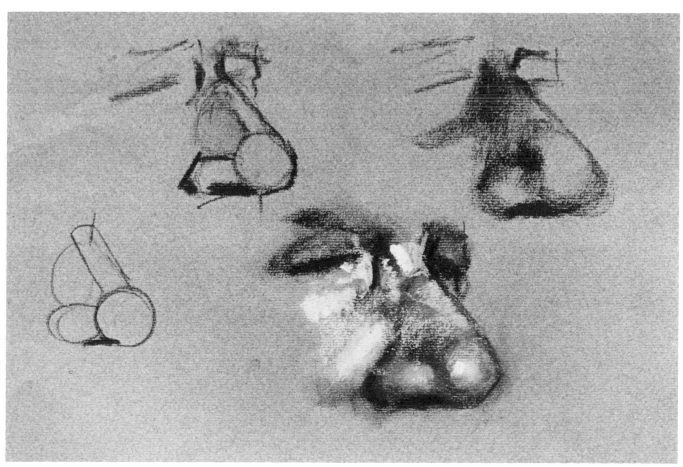

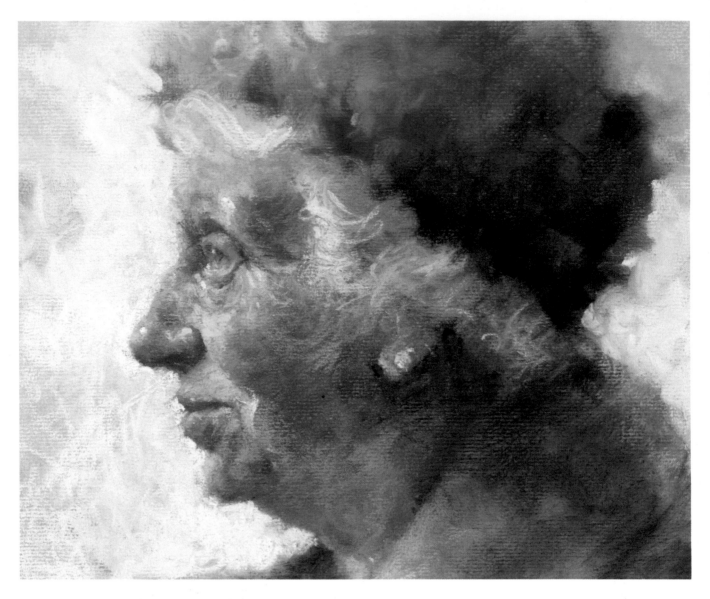

When a nose is seen in profile, its silhouette creates such a strong shape that it may not require the usual interplay of tones, textures, and colors to give it form, but on this full-face portrait of a confederate soldier, all these techniques had to be employed. I painted the background a strong white with a little cadmium yellow 1 (205.9) to add a degree of warmth. Since the eye is the center of interest, I placed tiny dashes of poppy red, cerulean blue, and grass green in the skin folds below it to draw attention to this part of the face. The tone and color of the nose play a subservient role, and I lightly dragged a stick of sanguine Conté crayon over a base of madder brown 0 (339.9) as the basic color for this feature. There are also extremely subtle touches of cobalt blue 0 (512.9) on the side of the nose playing against a mark of cerulean 0, a thicker mark of madder brown 0 (339.9) on the nostril, and a highlight of silver white (100.5) on the ball of the nose.

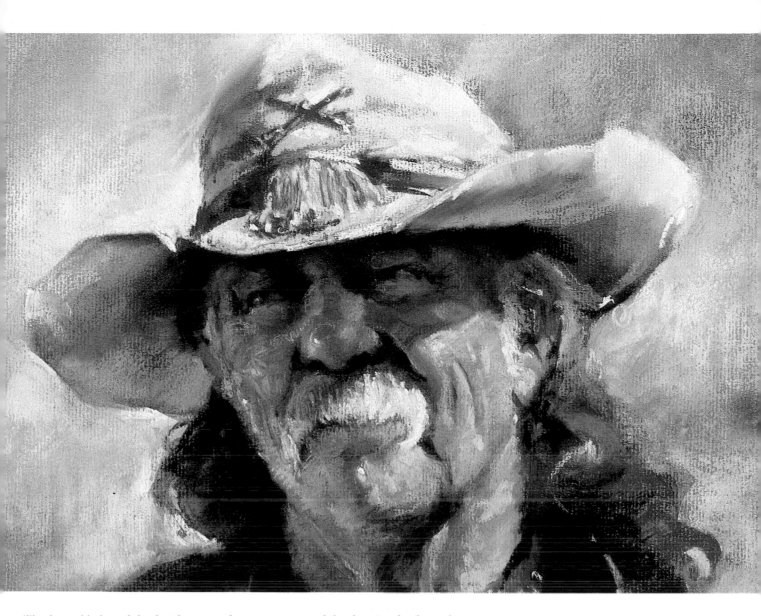

The broad brim of the hat has put the upper part of the face in shade and eliminated most of the light coming from above the features, resulting in the nose being lit from the sides. The bridge is in shadow with lighter areas at each side. Because of the strength of the light, the eyes are slightly screwed-up, the cheeks pouched, and the nostrils flared, giving the ball of the nose an even rounder shape.

The darkest areas on the face are in the corner of the eyes, below the nose, and at the left corner of his moustache. The tones across the nose are quite close in value, apart from the highlight on the tip of the nose. Since the soldier is not young, I used abrupt changes in tone, texture, and color on his nose to catch the weatherbeaten character of his countenance.

Once I had proportioned his face, I laid a basic skin color—madder brown 0 (339.9)—across the lighter areas of his nose. I rubbed-in this color, taking care not to make it look too even, which would make his skin appear soft and smooth. Next I placed a touch of poppy red 6 (318.7) on the ball of his nose to give it a bloodshot appearance, and rubbed it in so it blended in with the basic skin color. I used Vandyke brown 6 (717.3) to define the shadow areas below the nose, dragging the short pastel stick on its side so it picked up the tooth of the paper and produced broken color. On the bridge of the nose, I again smudged Vandyke brown. The result was a definite dark area of tone that made the lighter areas at both sides of his nose even lighter by contrast. By adding a little cobalt blue 0 (512.9) to the left side of his nose, I made this area lighter and cooler than the other side, where there was a warm highlight of lemon yellow 2 (205.7).

Ears

Because the ear is one feature that does not change with expression, I suspect that it is often neglected as a subject of detailed study. Ears vary enormously in shape and proportion and are as individual as fingerprints. However, the shape of the ear does conform to a general pattern and if painted in the right position on the head and proportioned more or less correctly, it may be acceptable to ignore the exact draftsmanship needed to reproduce it faithfully.

It is not necessary to spend a great amount of time learning to paint ears, but it is important to draw the size, location, general shape, and tone correctly. I simplify the shape of the ear by viewing it as a series of tubes, spheres, cavities, and channels, all joined in a curious manner. The color of the ear is obviously an extension of the individual complexion. However, I have found that the design of the ear does affect its color in that a fleshy ear has a more even distribution of color than an ear with sharp contours.

The top three sketches in each of these pictures show geometrical and tonal interpretations of ears. The upper left sketch shows the grouping of the basic shapes, the center sketch shows the darkest tones laid in, and the sketch on the upper right shows the ear with a complete range of values. As with the nose, much of the characteristic of the ear is produced by careful balancing of tone and texture.

The two lower sketches in each of these pictures show ears of different shapes.

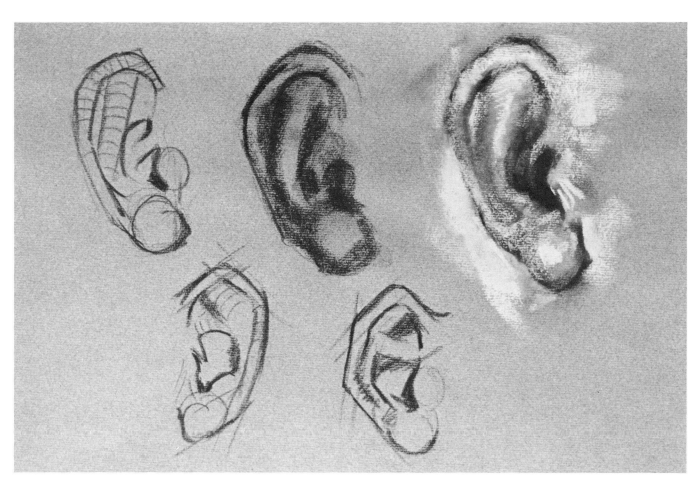

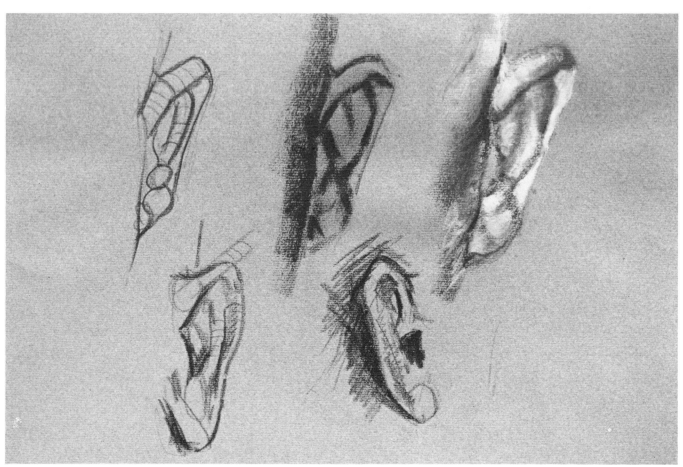

Hands

Hands are so expressive and play such an important role in revealing character that they should be included if possible. But because they can be difficult to paint, I recommend observing them (including your own) constantly, especially while people are talking. To understand how the hand moves, you must see it from many angles. You will also need at least a fundamental knowledge of anatomy to construct the hand and its parts accurately. And it is also important to know the proportions of the hand. (It may help you to know that my own hand, spread and measured from fingertip to wrist, equals the length of my face from hairline to chin.)

Foreshortening
Foreshortened hands and fingers offer one of the greatest painting challenges, and you will probably require a model to reproduce them accurately. Squinting your eyes will help you to see the values more clearly, while opening your eyes and viewing the hand normally will permit you to observe the foreshortened form. It is hard to give the illusion of foreshortening through linear drawing alone, but you will find that changes in value (from light to dark) and color (from warm to cool) will make the forms appear to advance and recede. You must also remember that if the hands are closer to the viewer (and artist) than the rest of the body, they will appear slightly larger than they would if they were further back in the picture.

Painting procedure
To paint the hand, you must first start with a convincing drawing. It may be light and sketchy, but if its proportions are correct, you will be able to add the values and color that will convert these lines to solid shapes. Later, when you become more experienced and confident, you can lay-in the tones and colors directly.

Years ago, when painting in oil I found that I could mix flesh tones more accurately by observing the colors on my own thumb as it pushed through the hole of my palette. I also noticed that, as I clenched and unclenched my fist, the blood was forced from the knuckles into the fingertips. This meant that bony areas had cooler colors than more fleshy ones—information that could also help in painting the face. On the following pages there are some quick pencil sketches of my own hand, together with examples of young, mature, and elderly hands and a study of clenched fists shown in greater detail.

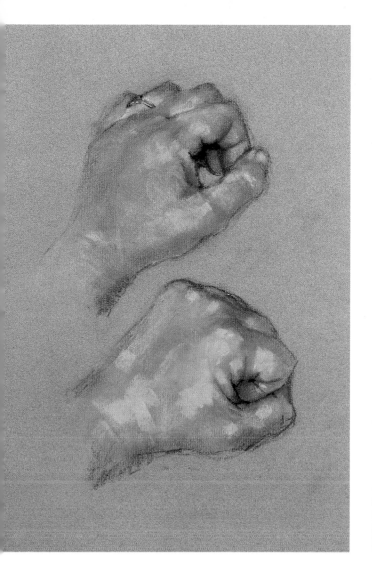

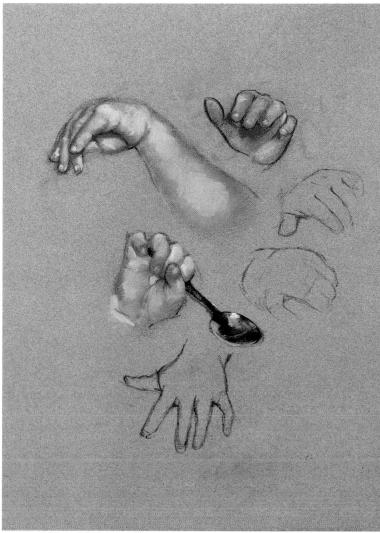

Practice hands by drawing your own. This exercise will give you plenty of practice in drawing the foreshortened adult hand. My own left hand has been a model hundreds of times, not only as a left hand but (with a mirror propped in front of me) as a right hand seen from the front.

Here my left hand is both clenched and relaxed. When closed as a tight fist, with blood drained from the knuckles, a strong tonal contrast is apparent. To give the effect of smoother, more tightly drawn skin, I built up the light values and sharpened the edges of the pastel strokes to indicate the bony structure beneath the flesh. In contrast, the relaxed hand was drawn with less pastel and with softer, more blended hues to produce a gentler form. Draw your own hand in this relaxed position and try to use value and color rather than line to define its shape.

The hands of a child are fat and puffy. This excess fat hides the bone structure and causes a baby's knuckles to appear as dimples. A child's fingernails are also smaller and are in proportion to their fingers and the hands are shorter than an adult's hands. Because of their excellent circulation, children's hands are pinker than adults' hands. The hands on this page were painted with a thick build-up of pastel, rubbed-in well to create a balloon-like form.

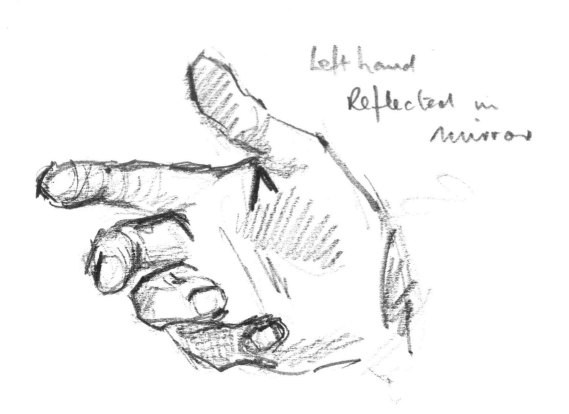

Left hand
Reflected in
mirror

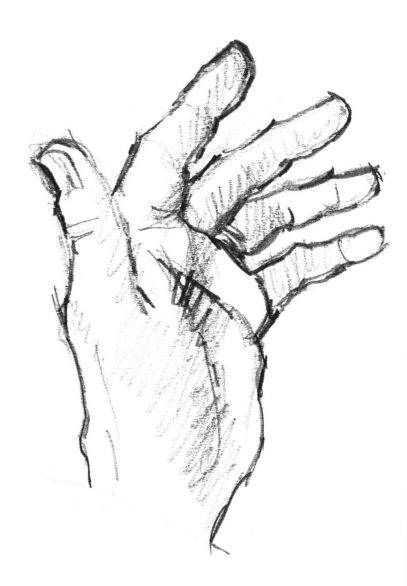

'Left Hand
steld

64

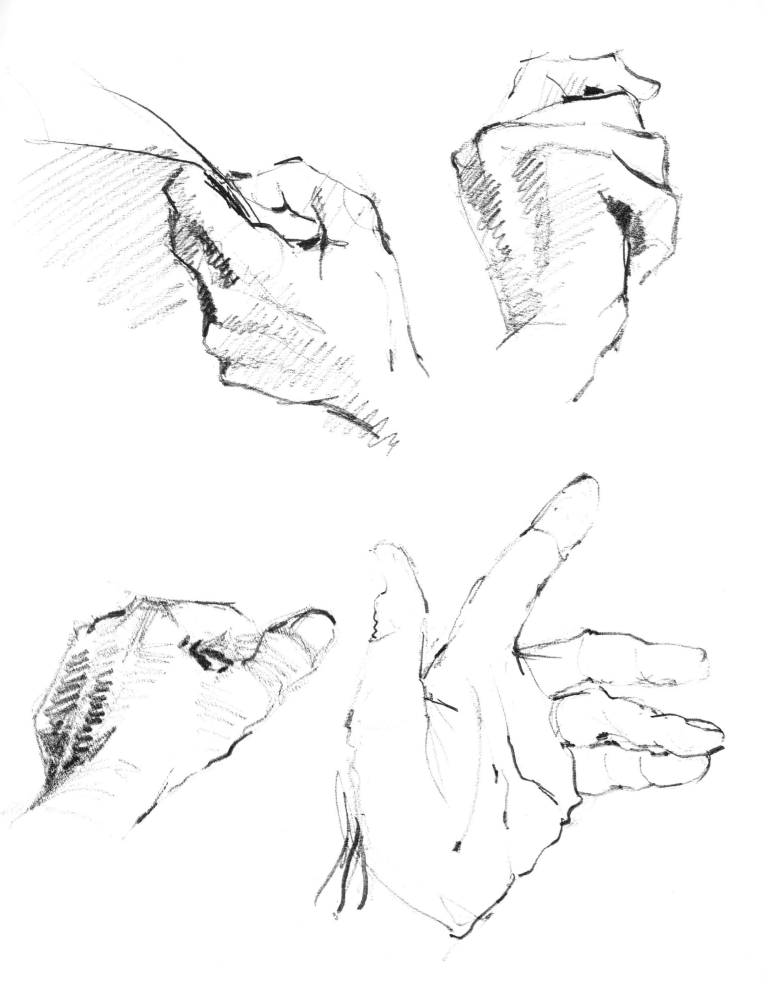

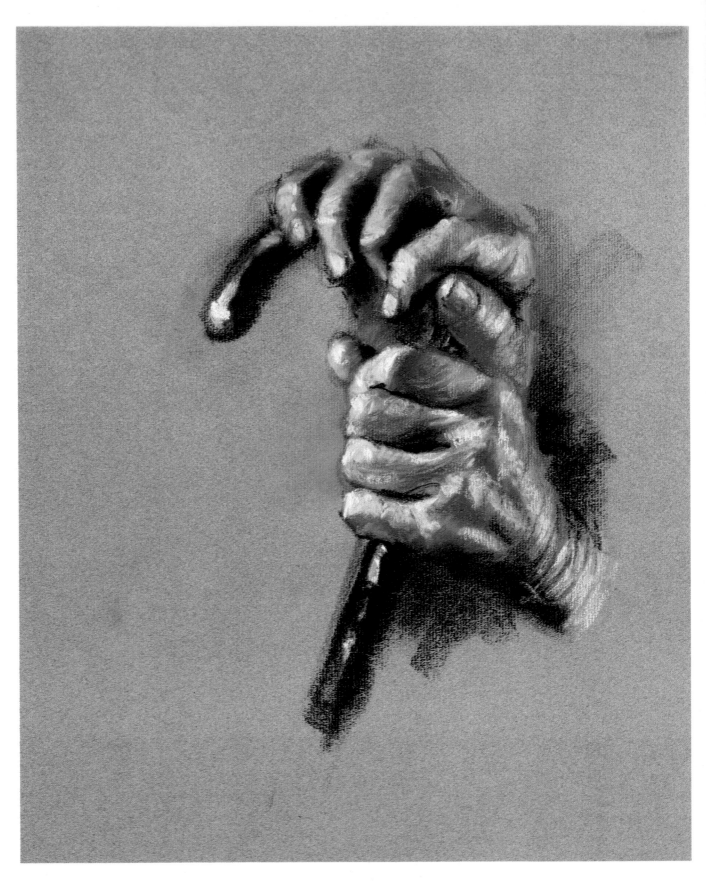

When an elderly hand is clenched and twisted, the loose skin is stretched
taut. Fingers and nails are angular and clearly define the underlying bone,
making the hands appear brittle and fragile.

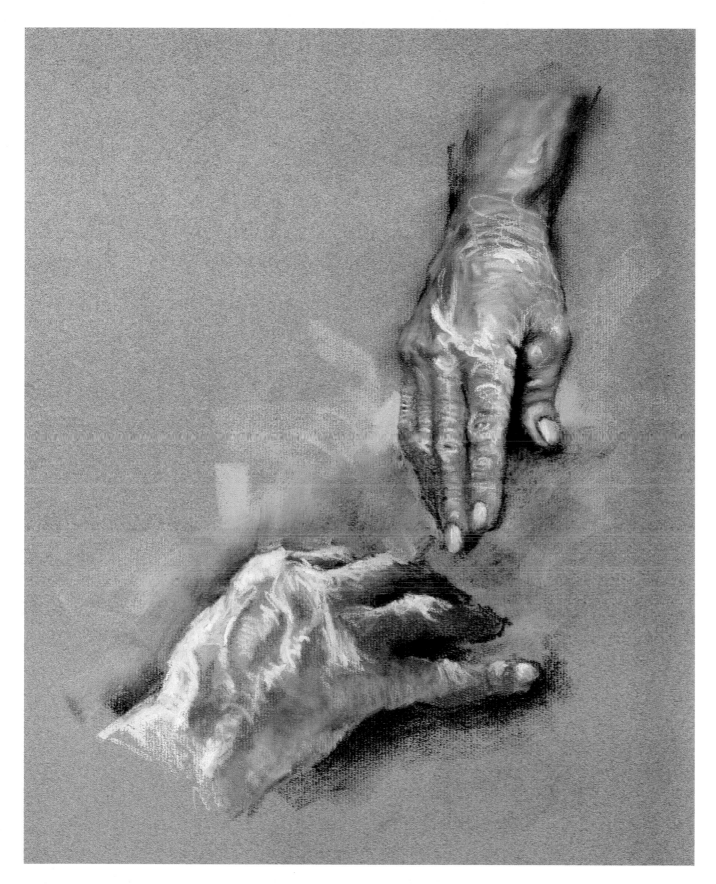

Even though this aged hand is at rest, the whorls and folds are evident.
The skin lacks elasticity and the sagging flesh hangs loosely from the
bones. The flesh is thinner than a younger hand and the veins and
tendons are much in evidence. The skin is gnarled and because the
circulation is more sluggish the hands appear yellow.

Hair

Painting hair in pastel is much easier than it looks. This is because it is the general shape, texture, and color of the hair that enhances the personality, whereas it is the fine details of the facial features that confirm the characterization.

The girl on the opposite page has a lot of hair and it plays a strong part in portraying her character. In contrast, the Chelsea pensioner on page 89 has very little hair; it is his watery eyes and the texture of his skin that define his character most clearly. However, the exaggeration of the wisps of hair at the side of his head and his drooping mustache also help portray his personality.

There are three main areas to remember when painting hair: texture, growth, and color. The texture of the hair is best portrayed by the use of tone. The direction of the hair's growth is best shown by directional strokes of pastel and by rubbing-in the highlights in the same direction as individual strands. As for color, on the whole hair colors are low in key in terms of vibrancy, so it is therefore better to rely on slight exaggerations or contrasts in value (tone)—not color—to enhance its appearance.

It is not a good idea to try to use masses of hair to cover up a badly drawn head shape. You can get away with it sometimes, but not very often. The examples of hair in this section are limited to a basic tonal formula. If you apply the principles outlined above to other portraits in this book, you will be able to figure out how each head of hair was painted quite easily.

Stage 1
In this portrait, the hair plays an important part in establishing the character of the woman. I began by drawing an outline of the shape of the head and proportioned the facial features as described earlier. I blocked in the darkest areas of the hair with black pastel, adding a few sharp lines to show the shape of the hair and direction of the gentle curls.

Stage 2
Next, I applied Vandyke brown 8 (409.3) to the lighter areas of the hair and to the shadows of the face. I blended these tones together by rubbing in with my little finger. The hair is a dense black at this stage. Close inspection shows that the darkest areas of hair have been rubbed-in well, while the middle tones are produced by the paper showing through the lighter areas of pastel.

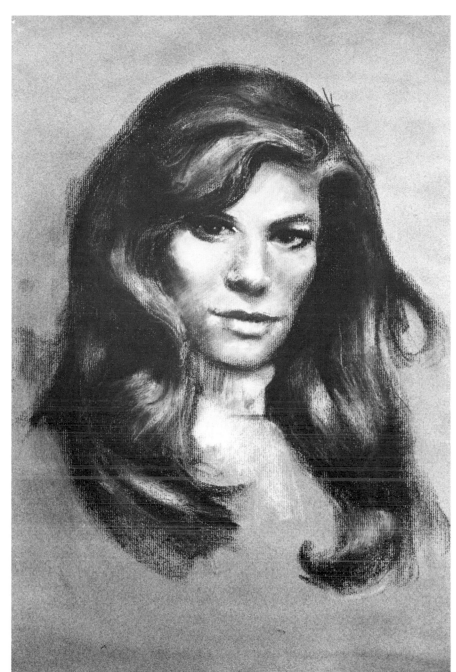

Stage 3

I toned the face with madder brown 0 (339.0) and white and then used a short piece of white pastel on its side to show the exact highlight and form of the hair. I graduated the edges of these highlights by gradually decreasing the pressure on the stick of pastel so that the white blended into a gray and into the dark areas of tone. Notice that I have suggested the occasional stray hair that catches the light and gives interest, but in the main I have portrayed the hair as a layer of soft and pliable material that conforms to the shape of the head and falls quite naturally.

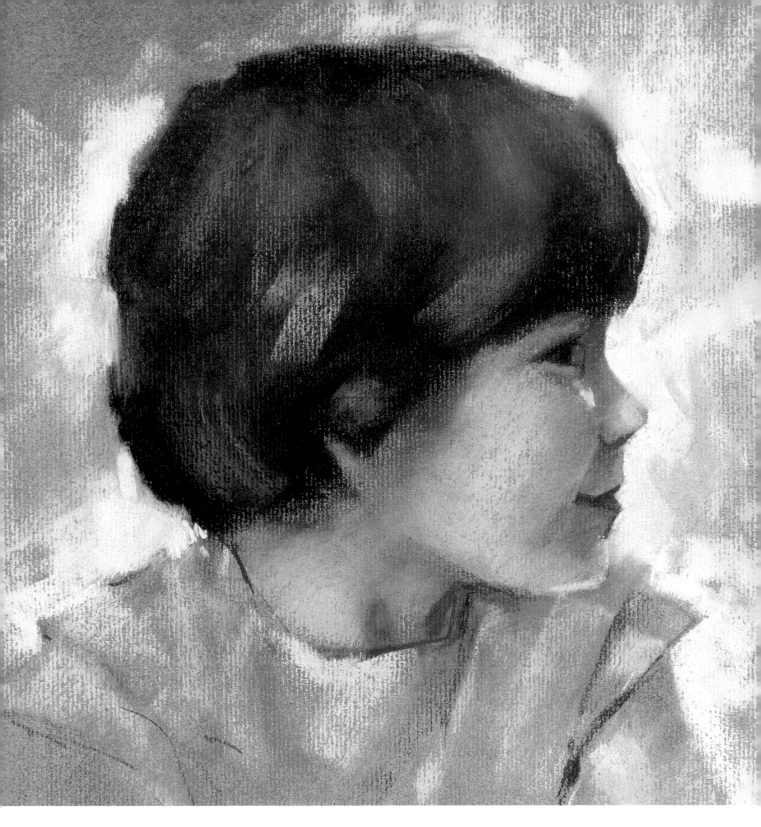

This young girl's hair is light brown, slightly wavy, and fits closely around the shape of her head. I began by laying-in the lower edges of her hair with Vandyke brown 8 (409.3). Then I overlaid Vandyke brown 6 (717.3) on the top area of her head. Then blended these two colors gently so that the weight of darkest tone was distributed along the bottom of her hair. The hair follows the shape of the head, which is shaped like a ball. Light reflecting on the hair produces the palest tones in the middle of the head, giving shape and form to the hair. I added a light glaze of sanguine Conté crayon to give a slight warmth to the hair and followed this with some strokes of Naples yellow 2 (202.9) applied with varying pressure to suggest the lighter parts of the hair.

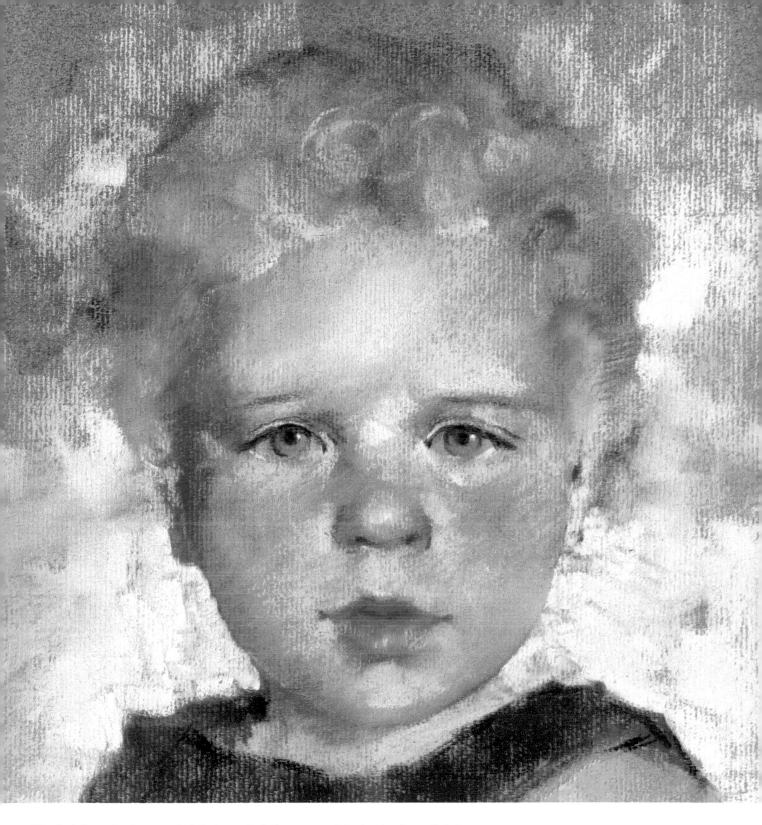

The hair here is short and tightly curled. I suggested its basic shape lightly with Vandyke brown 6 (717.3) and then added a glaze of sanguine Conté crayon over this. I defined the highlights in the hair with yellow ochre 2 (202.7) and then reestablished dark areas with the Vandyke brown to give it a little extra form. To portray small, tight curls of hair, I used circular strokes of sharpened pastel and, for once, made no circular rubbing-in strokes with my little finger.

Composing Heads

I normally regard most compositional rules with a certain amount of skepticism since I have seen paintings that turned the most sensible composition formulas upside down and were still entirely successful. The paintings in this section show some of the simple, general rules of composition in practice. When painting a formal pastel portrait, it is a good idea to imagine a fulcrum in the center of the sheet of paper and balance the shapes, values, and colors around this fulcrum. For a more striking or controversial portrait, however, an imbalance of these shapes, values, and colors can produce an unexpected effect.

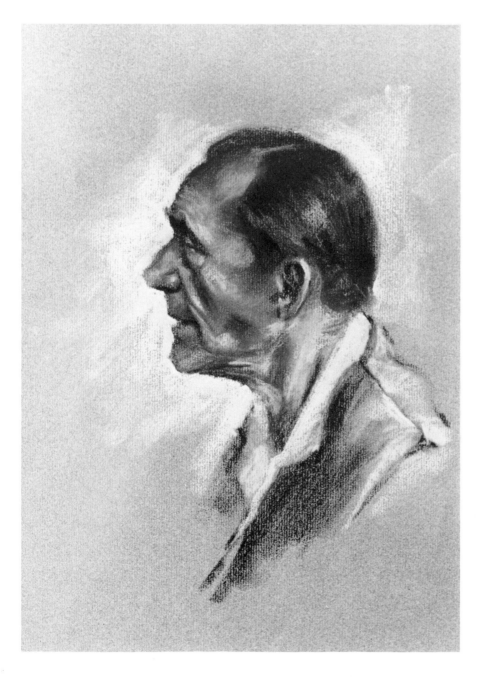

The straight profile at left has been carefully balanced around the center of the paper. Because the man is looking to the left, there is more space in front of his head than behind it so that he does not appear to be looking at the very edge of the picture. Because there is more action below his face (the visual center of interest) than above it, there is consequently more space from his chin to the bottom of the picture than from his hair to the top. In the example above, the random placement of this head has resulted in a very awkward painting. The large areas of space above and behind his head serve no purpose other than to upset the visual balance around the head.

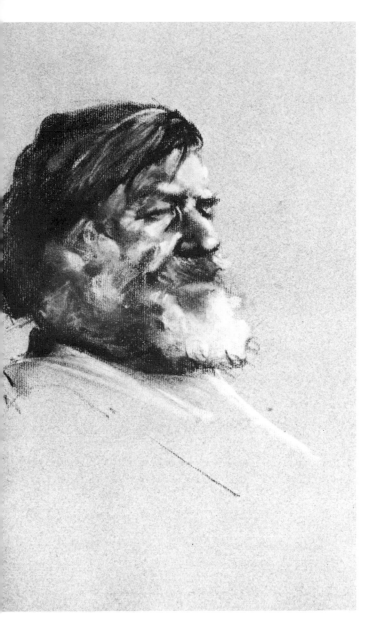

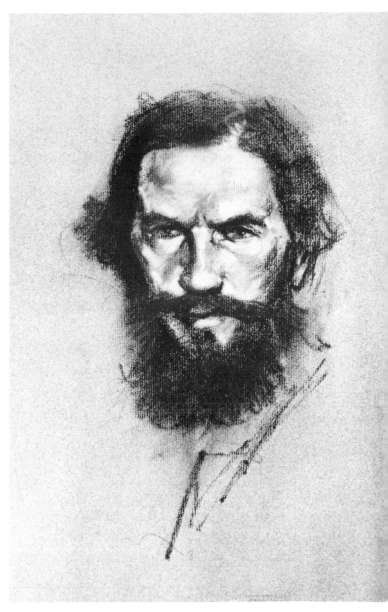

When painting the face from a three-quarter angle, use the same rules as in the balanced composition on the preceding page to achieve a satisfactory composition. In general, always allow more space in front of a face than behind it so that there is something for the person to "look into."

For a full-face portrait, leave equal amounts of space at either side of the head. Here, because the eyes are cast slightly downward, the head has been positioned above the center of the paper area to give a feeling of space in front of the head. When painting a head and shoulder portrait of a very tall person, it's a good idea to position the head close to the top of the paper. Even though the whole figure is not visible, this placement will enhance the impression of height.

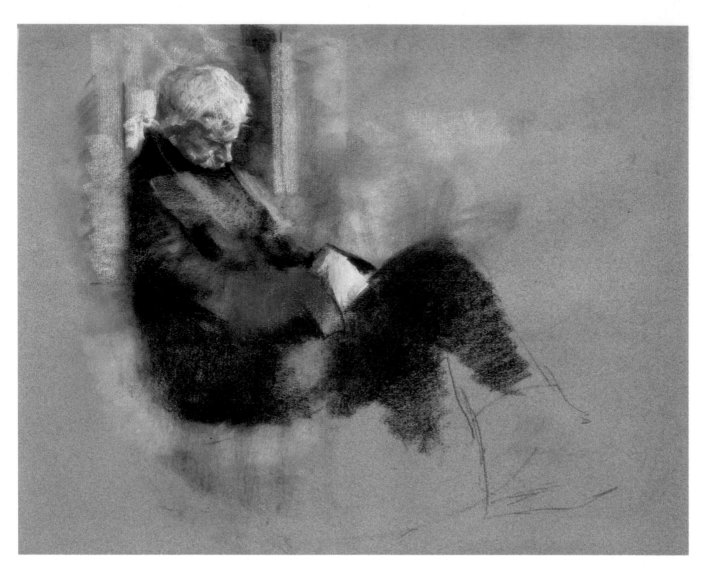

(Above)
This partly worked drawing is a study for the finished painting on page 132-3. A comparison of the finished painting and this study show that the original composition was unsatisfactory. This is mainly because the "down-and-out" figure was not as effectively presented while sitting more upright with just the head slumped, as when slouched near the bottom of the paper as in the finished painting. In this study I placed broad vertical stripes of Naples yellow at either side of the head to suggest the portals of a doorway, but when I made the finished painting, I realized that these were entirely unnecessary and just produced an awkward directional pull. In the study, I made provision to draw the tramp's thighs, legs, and feet as part of the painting, but later realized that the painting would be far more effective if I showed just his waist and knees.

(Right)
Without the balloon, the little girl would be in a very strange position on this sheet of paper. You can prove this by covering up the balloon with your hand to see how awkward the composition becomes. If you position an imaginary fulcrum in the center of the sheet of paper, the shapes, values, and colors all balance each other at this point to produce a finely poised portrait. The juxtaposition of the white background against the light yellow and warm dark color of the balloon at the top of the paper is an ideal foil for the dark background and the lighter colors of the girl's flesh below.

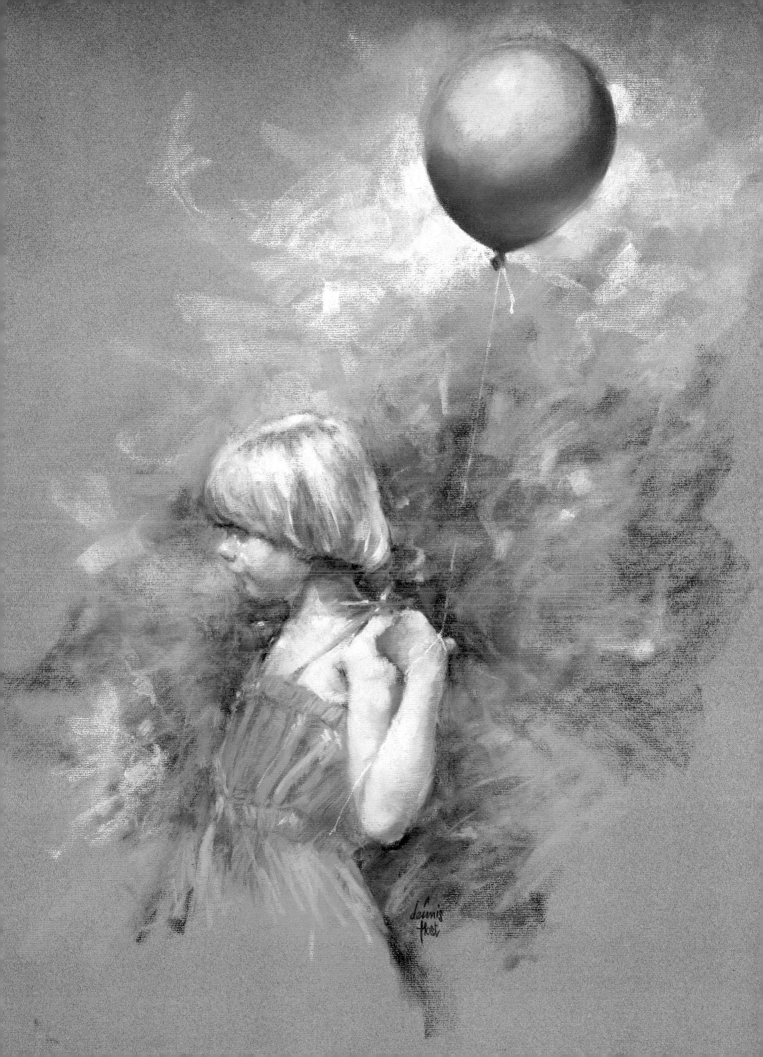

Paper Texture

The best way to capture character is to create an *impression* on the paper and in the mind of the viewer. This is sometimes achieved by slight or forceful exaggeration of line, tone, or color to create an overall pastel texture. Paper surface is therefore critical in enhancing the desired effect, as is obvious in the examples on these two pages, all of which provide complete contrasts in paper tooth, application of pastel, tone, and color.

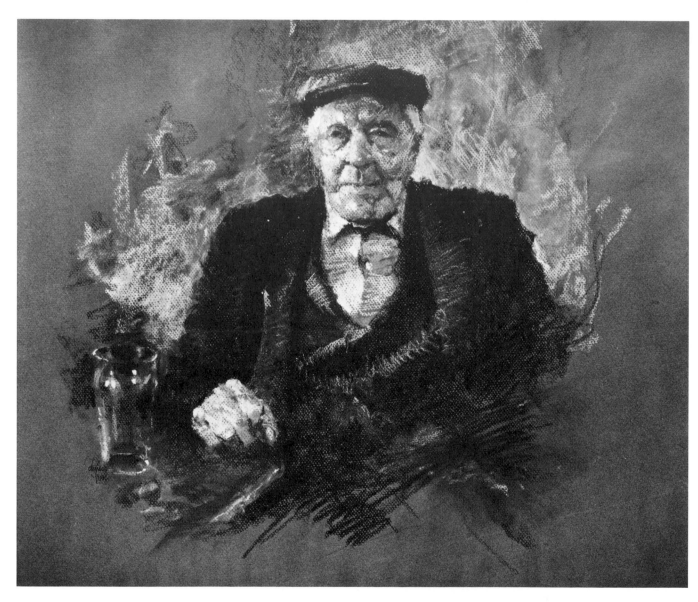

The painting of this elderly man was done on Canson Mi-teintes, a paper with an exceptionally heavy tooth and a good dark color for this mostly low-key study. Since the paper itself decides the amount of pastel it will accept, on coarse paper it is necessary to press much harder with the pastel stick to fill the tooth. But because coarse paper rejects an overall cover of pastel, it conveys a more rugged image and enhances the interplay between areas of broken, textured tone.

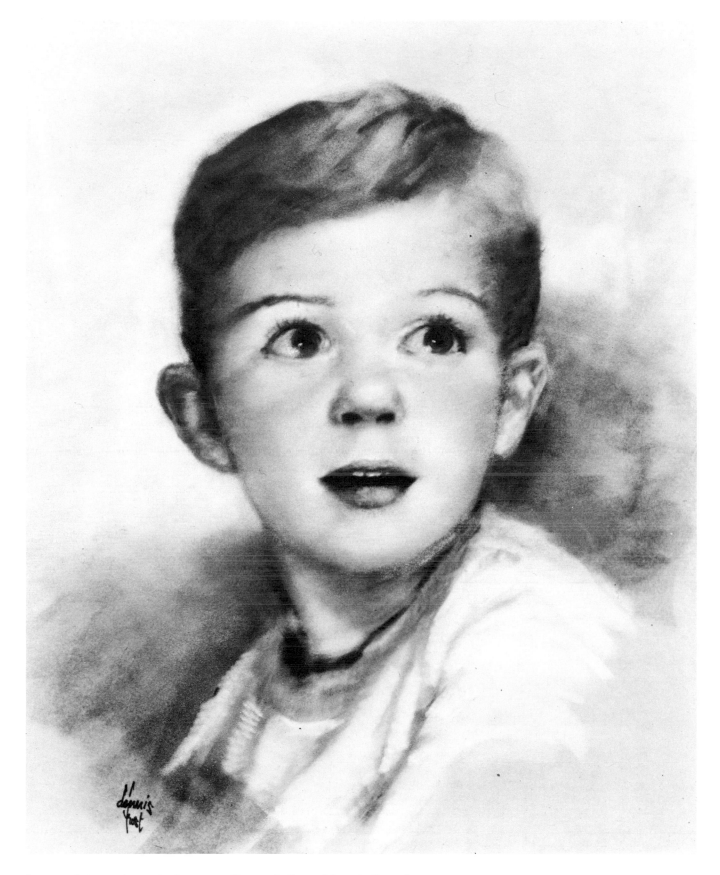

In complete contrast, to the preceding painting, this painting of a young boy was executed on a piece of wallpaper that has a soft, velvety finish because it was sprayed with flock. ("Flock" is a finish achieved by spraying fibers onto paper, giving a texture between velvet and baize.)

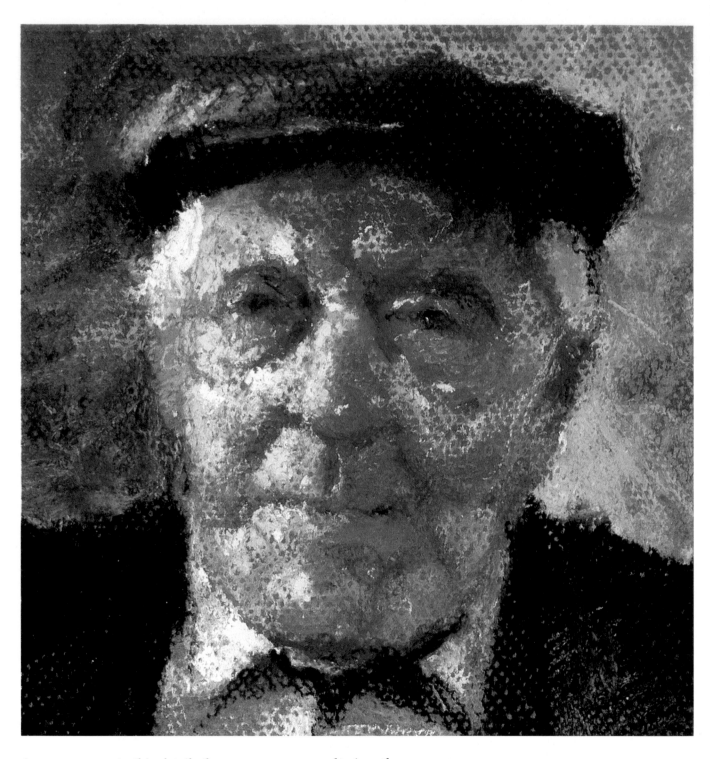

As you can see in this detail, the coarse paper emphasizes the craggy features of the old man's face. I also used short, oblique pastel strokes to create the effect of aged skin. But I could not make these marks any coarser or the whole face would have broken up into a mess of blobs of color and the overall form would have been entirely unrecognizable. Instead, I got the blotchy effect of his skin by using a coarse-toothed paper, which made it possible to introduce sufficient texture within each pastel stroke to giving maximum fragmentation to his face while retaining facial identity. This elderly man's character is portrayed entirely by the color and tone of his flesh. For once, the eyes are quite undefined and his mouth fully relaxed and showing no sign of tension, happiness, or depression.

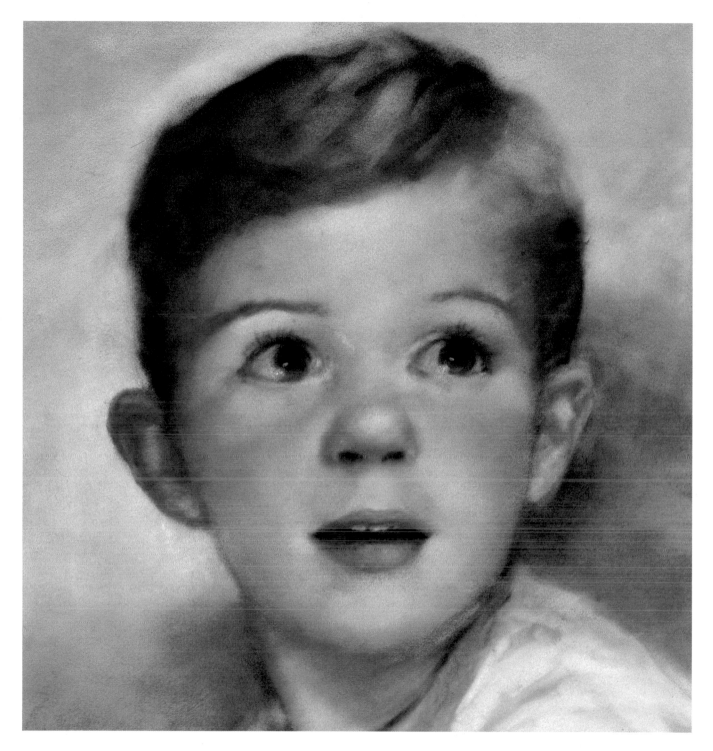

In this detail of the painting of the young boy, you can see how the soft paper enhances the "candy-box" effect of this portrait. There are almost no sharp changes in value; each tonal variation has a blended edge. The eyes have a misty look, created by smudging the highlight along the lower part of the eyeball, and the upper eyelashes are sweeping and pronounced. The slightly open mouth suggests an expression of wonder. It is hard to believe that both these portraits were made with the same medium, which just goes to show how much variety can be achieved through skillful handling of pressure, rubbing-in, and paper surface.

Matting and Framing

Pastel paintings are best framed with a mat between the work and the glass. This serves two purposes, to enhance the presentation of the work and to separate the painting from the glass, preventing the transfer of pastel dust on to glass which can be extremely unsightly.

To cut a mount, use a sharp mat knife with a steel blade. Cut at an angle to produce a bevelled edge, cutting slowly, evenly, and firmly, and finish the corners with a razor blade if necessary. Some pastel paintings are framed without a mount—a method known as "close framing." To keep the pastel from touching the glass, insert a strip of wood 3/16" (4mm) square around the frame edge, between the glass and the painting.

Before framing, hold the painting high—between finger and thumb at one of the top edges—and tap the back of the paper several times to remove all loose particles of pastel dust.

You can buy framing kits, but these are usually fairly rudimentary. Frames made professionally are expensive, so the obvious solution is to make your own. However, cutting accurate miters and joining them yourself is not as easy as it looks but demands practice and the correct tools for the job. There are some excellent books available on the subject, including *How to Make Your Own Picture Frames* by Ed Reinhardt and Hal Rogers (Watson-Guptill), and I advise you to invest in the words and pictures that will give you the exact expertise for the job.

Over the years, I have made many frames for my paintings and have eventually achieved a standard that could be called proficient. One fact has emerged from this: A good frame will sell a poor picture, but a bad frame will ruin a good one.

Demonstrations

I painted these demonstrations to show how to handle pastel to portray personalities. Each demonstration has a theme that isolates a specific feature in the subject or shows one or more specific techniques in progress. For example, although this is not the only way to paint, I work from dark to light in value. This one, like other techniques that I use, has been developed over the years from my own trial and error methods and, for me, they work. Try them yourself and see if they suit you. But remember, there are no shortcuts. You eventually must learn to know and understand your own materials and develop your own procedures and be prepared to learn from your mistakes. I hope my experiences will prove useful to you.

One last comment: Each stage of these demonstrations is a separate painting, not a development from the previous stage, so, because of this, there are minute variations in detail. I hope you will ignore these minor deviations for the sake of the overall purpose of these demonstrations.

Chelsea Pensioner
Exaggerating features to create a stronger impression

I have a passion for painting old people. Their expressions contain a lifetime of experience and their features have a great variety of subtle differences in color, texture, and form. In old age, features change and mellow remarkably. An old man's hair may be gray and thick or bright, white, and thin. His skin may be dark and polished like well-tanned leather; pale, loose, and blotchy; or highly colored and rosy from many tiny veins. His eyes, set amid wrinkled skin, may be dull and tired or sharp and bright. I am always excited by the challenge of trying to capture these subtleties and to do justice in pastel to a fine old face.

I came across two elderly pensioners on a park bench in Chelsea in the shade on a hot day. One of them, in particular, fascinated me. Although he had no outstanding features, he possessed a quiet dignity that often comes with advanced age. His eyes were faded, but they had an alert, birdlike quality, his smile was strong, and his colorful nose and cheeks added further warmth to his expression. His bright, heavy coat hid a frail figure, and he obviously took great pride in his medals.

Later in my studio, when I studied my sketches, I pondered his features over and over in my head. I was eager to do a portrait that would capture the qualities of his character—the sharp, bright eyes set in the aged face of a man well into his eighties.

Stage 1
To capture the full character of this aged gentleman, I decided to paint him as a close-up portrait. I began by freely sketching the head and shoulders with soft black Conté crayon. Once I had established the correct proportions, I shaded-in lightly the areas of dark tone, then reinforced them with madder brown 8 (373.3) and blocked-in the eyes with blue gray 4 (727.7). I find that the application of color at this stage gives me a guide to visualizing the head in a solid form. I frequently draw upper lips too long, but because his moustache completely hid his upper lip and mouth, I was able to evade the problem entirely.

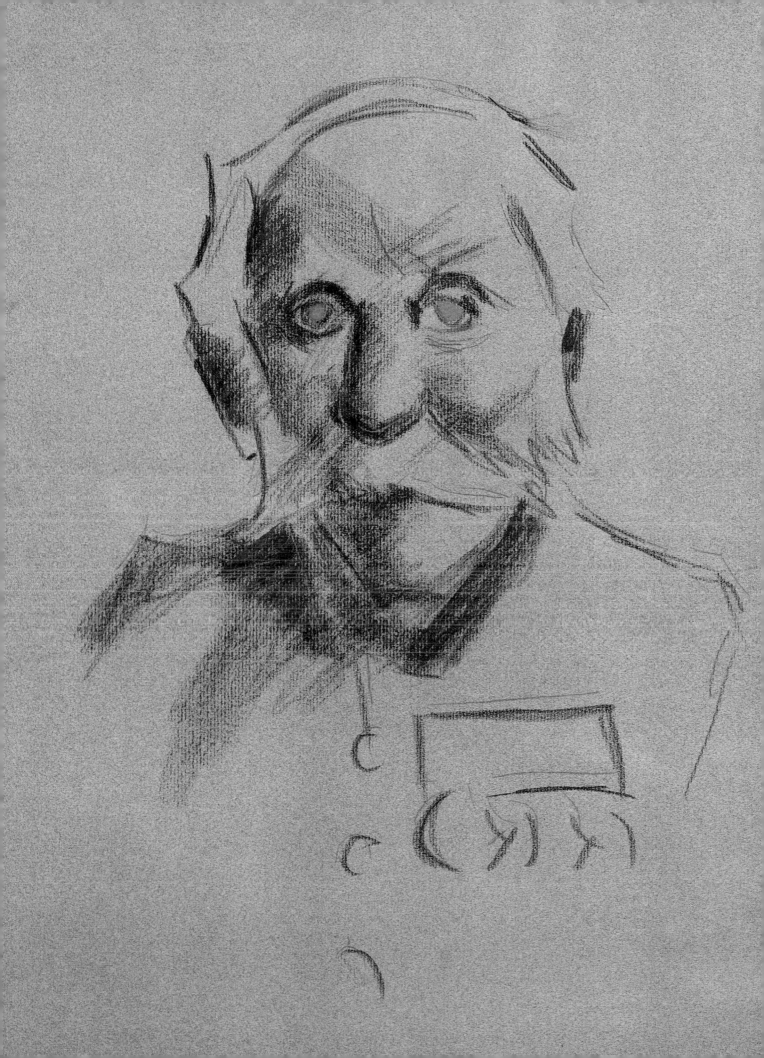

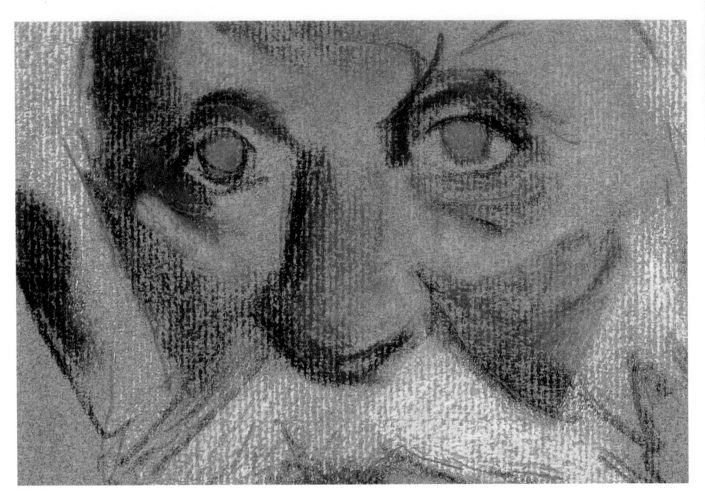

Detail, Stage 2. I used white to block-in the hair, moustache, and medals, and madder brown 0 (339.9) for the flesh tones, with a little poppy red 6 (318.7) to indicate the warmer areas. This color was also used for the bright coat.

Stage 2

I built up values and introduced color slowly, so that there was a gradual, balanced development of tone across the painting. I was concerned only with stating light and dark areas, not with indicating detail or any form.

I have great difficulty working from light to dark with pastel. I find it much easier to work back from the darkest areas, overpainting with lighter tints and dusting them off to reduce the strength of their color. That way, a painting never becomes too dark and overbearing, but usually preserves many areas where there is a satisfying effect of light and color.

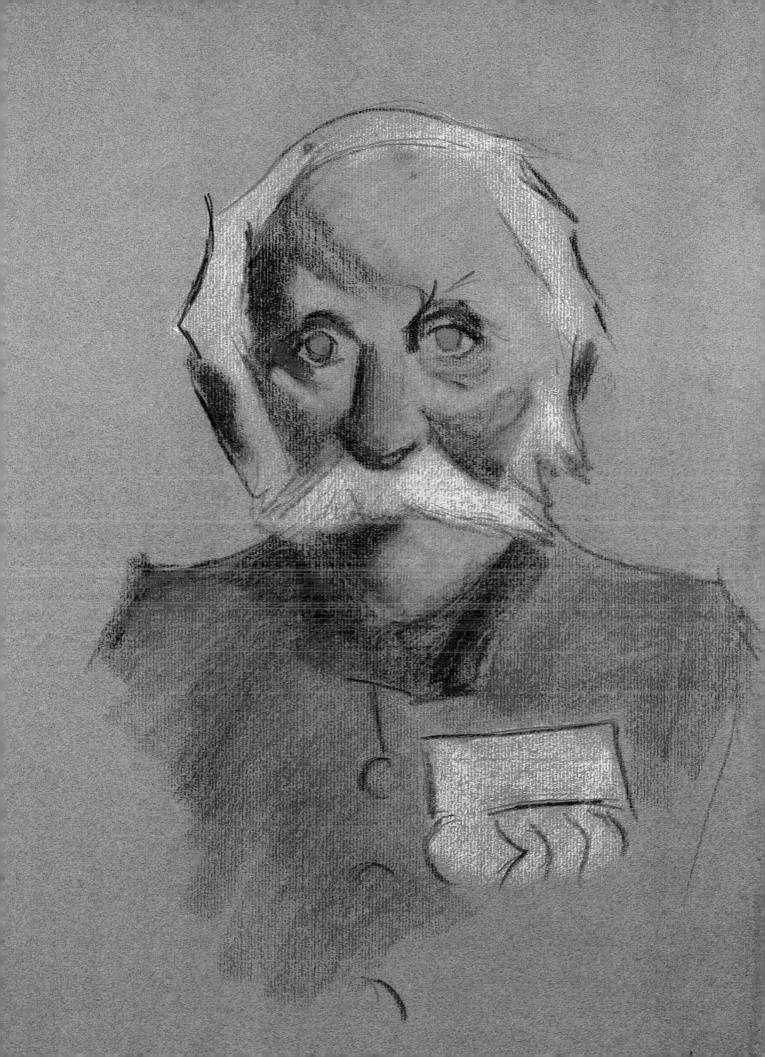

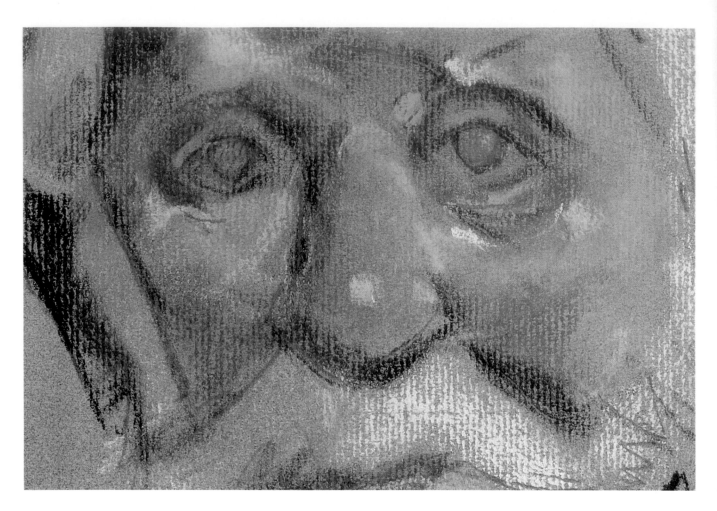

Detail, Stage 3. It looks as if there is more color on the face at this stage than there actually is, but in fact very little has been added. It is the rubbing-in that has built up the strength of the features.

Stage 3

At this stage I began to create form and more subtle tonal values by rubbing-in some areas with the little finger of my drawing hand. This gave a unifying effect. Then I overlaid the shadows on parts of the hair and moustache with blue gray 4 (727.7) and added a few touches of poppy red 6 (318.7) to his cheeks and coat.

I put in a few strokes of black Conté crayon around the coat collar and described the medals with cadmium yellow 1 (205.9). I also experimented by adding "acid" colors—very light, cold color that could be a sharp highlight—around his eyes, finally settling for mauve 2 (547.9) and grass green 1 (618.9). Color can create a mood or describe an age, and the colors I chose here were ideal for expressing old skin. (I find the best way to describe pores and skin texture is by making tiny patches of subtly related color.)

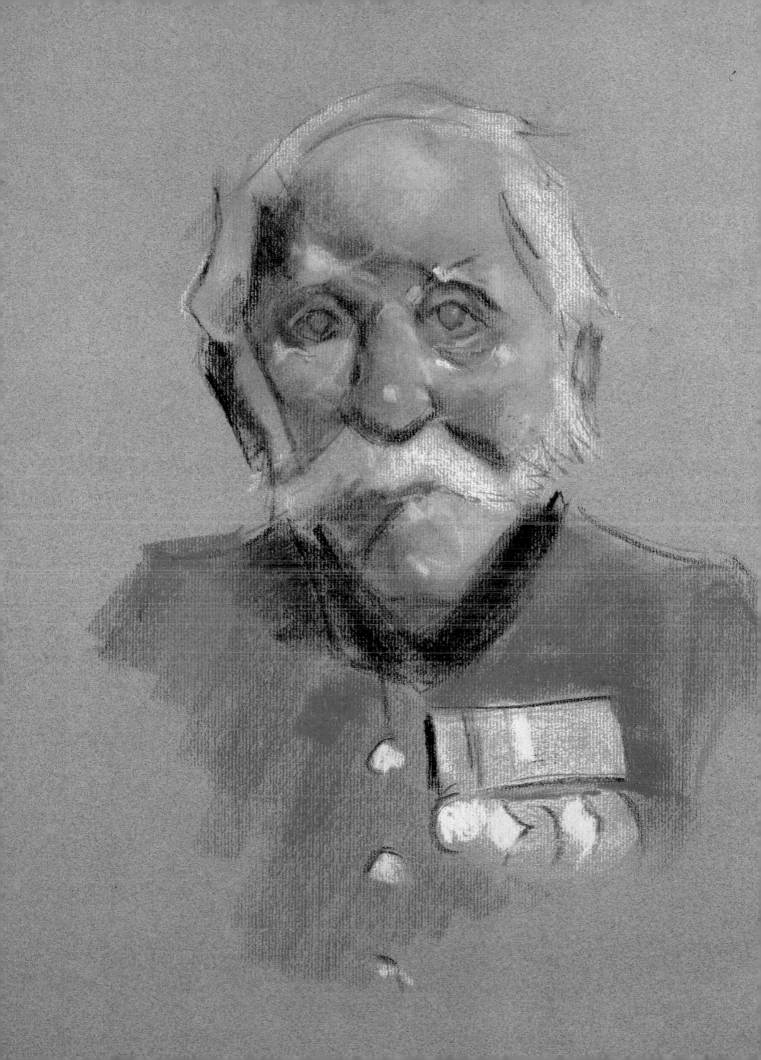

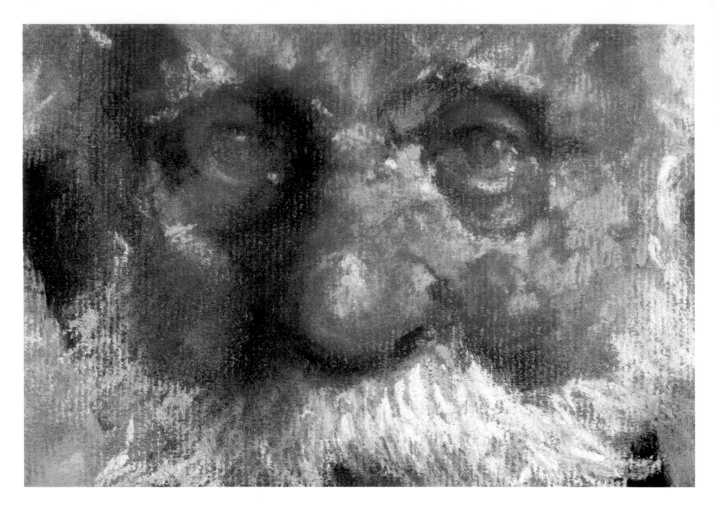

Detail, Stage 4. I modeled the shapes of the eyeballs with my finger and overpainted the black lines around the pupils and edges of the eyelids. By leaving them thus ill-defined, they began to take on a watery appearance, and with a touch more madder brown 8 (373.3), I aged his eyes. I deliberately understated the highlight in his eye to avoid giving him a youthful glint, which would have upset the entire portrait. I worked around his eyes in tiny stabbing strokes of intense colors and put into his cheeks and chin some highlights of madder brown 0 (339.9). I treated the moustache with strong directional strokes of white and darkened some of the small shadows, giving the illusion of greater form. Wispy white strokes of pastel gave the hair and eyebrows just enough definition.

Chelsea Pensioner, 1980, Canson Ingres Tint 55, 12″ × 15″ (30 × 37 cm).

Stage 4

The painting was dusted down with a 2″ (50 mm) varnish brush to give it a muted effect, in preparation for fresh pastel strokes. I left the top of his head understated and eliminated all signs of the hard black lines visible in Stage 3. Two broad strokes of madder brown 0 (339.9) gave a little prominence to the forehead, and behind them I added a hint of grass green 1 (618.9) to give recession. Mauve 2 (547.9) worked into the hair on the top of his head diminished its strength and gave more emphasis to the rest of the hair on his face. Then I turned my attention to the eyes and moustache (see detail). Finally I painted his coat and medals. I blocked-in the collar with Rembrandt black pastel and overlaid blue gray 4 (727.7) for the light areas. I strengthened the coat to a rich red with poppy red 6 (318.7), and gave shadows and form with mauve 2 (547.9) and Vandyke brown 6 (717.3). I stated the medals with precision and detail so that they appeared well cared for as his prized possession. I then broke up their form a little to harmonize with the rest of the portrait. To complete the painting, I added some loose strokes with the sides of white, grass green 1 (618.9), madder brown 0 (339.9), and mauve 2 (547.9) pastel sticks, emphasizing the fall of his shoulders to add a final touch of age.

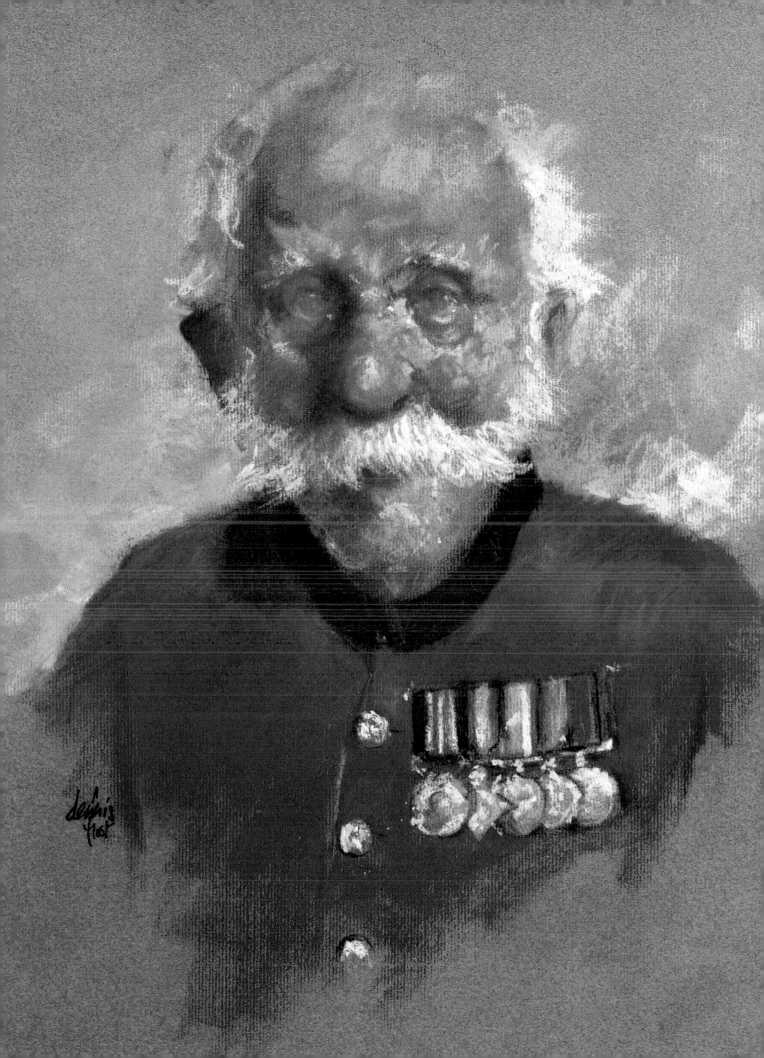

Morris Man

Capturing rhythm and gaiety

The morris dance is of Moorish origin and is performed in traditional costume to the staccato rhythms of pipe, fiddle, and accordion. When the morris men come to town and perform these ritual dances outside an inn on a hot summer evening, there is always a lively atmosphere and plenty of drinking and dancing.

The dances provided me with an excellent opportunity for a painting. The accordionist was particularly fascinating because he had rhythms of his own. The angle of his stance, the sweep of his arm, and the bright colors of his costume all contributed to a riot of activity.

Stage 1

In this study, I wanted the attitude of the figure to reflect the occupation of music-making, so I planned a rhythmic composition to evoke this. The initial sketch was made with a bistre Conté crayon and the warm darks were stated with madder brown 8 (373.3). In contrast to these areas, I laid in some cold dark tones at the lower part of the drawing with blue gray 6 (727.5), then countered these with madder brown 0 (339.9) for the flesh and white for the hat and shirt, so that I soon had an overall impression of the direction of my plan.

It is always tempting to work on only one small interesting area and build it up, but this almost invariably leads to conflict at a later stage because the area has developed out of harmony with the rest of the painting. So I make it one of my golden rules to maintain an overall pattern of work, with frequent checks to see that there is no discord or that no one part is developing out of proportion.

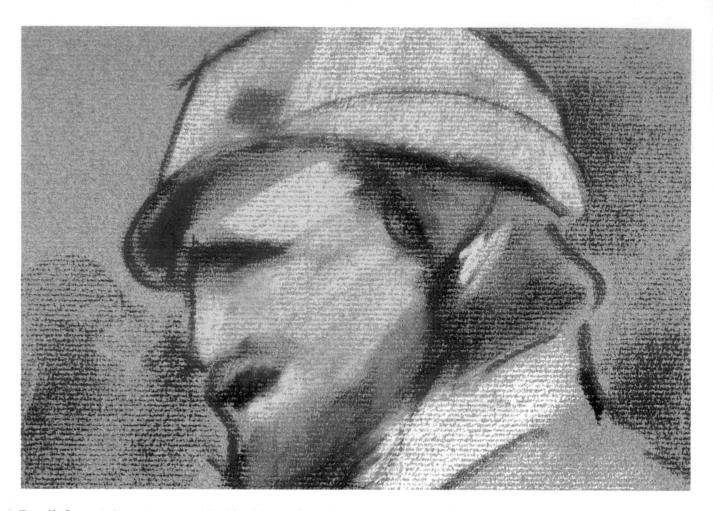

Detail, Stage 2. I continue a gradual build-up of tonal counterchange until there is just enough pastel on the paper to make the desired statement. This gradual build-up also gives me confidence.

Stage 2
I lightly dusted the entire picture to reduce the richness of some of the colors, then blocked in the accordion with poppy red 6 (318.7) and cadmium yellow 1 (205.9), using white for the highlights and a touch of Vandyke brown 6 (717.3) for the shadows on the bellows. I used cadmium yellow 4 (201.5) to lighten the hair and the beard; blue gray 6 (727.5), a neutral color, for the basic background tone; and sap green (201.3) to draw the sash and rosette.

I continued to work from one part of the painting to another, keeping each new color weak at first and gradually relating the tones on one side of the body to those on the other, as I do in many of my paintings.

While I don't wish to ruin a painting by working too quickly, I hasten to reach the point when I believe that the picture is beginning to work and when I can start to use stronger color, make more dramatic tonal changes, and interplay a variety of marks and shapes by varying the pressure and using different parts of the pastel stick.

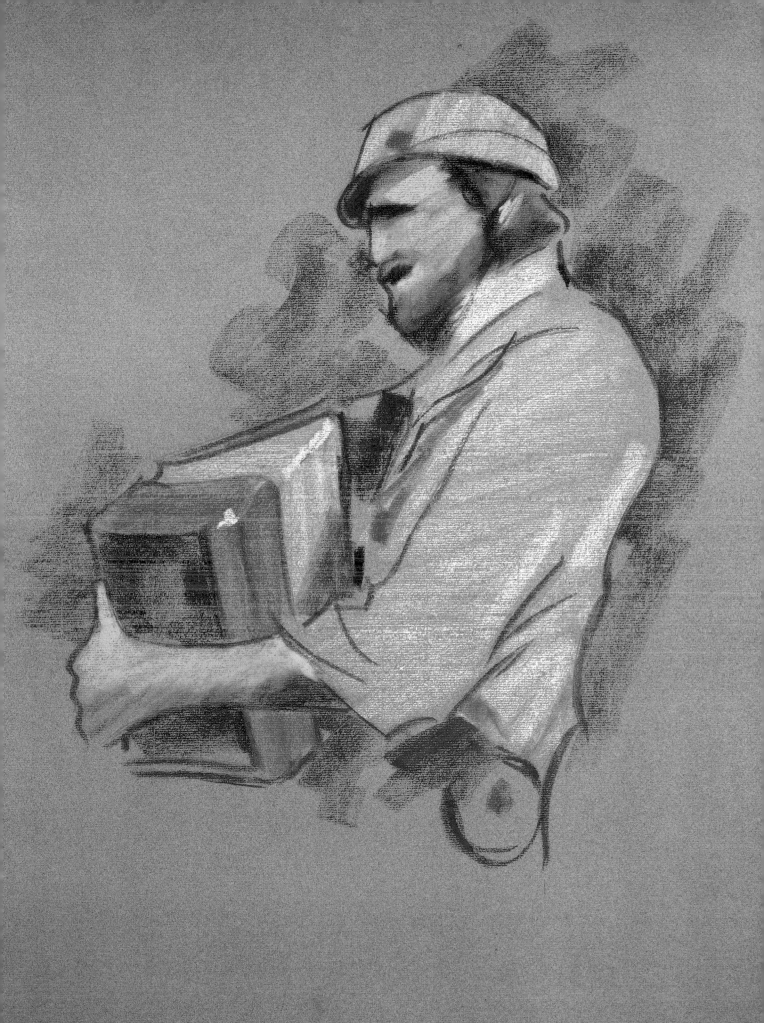

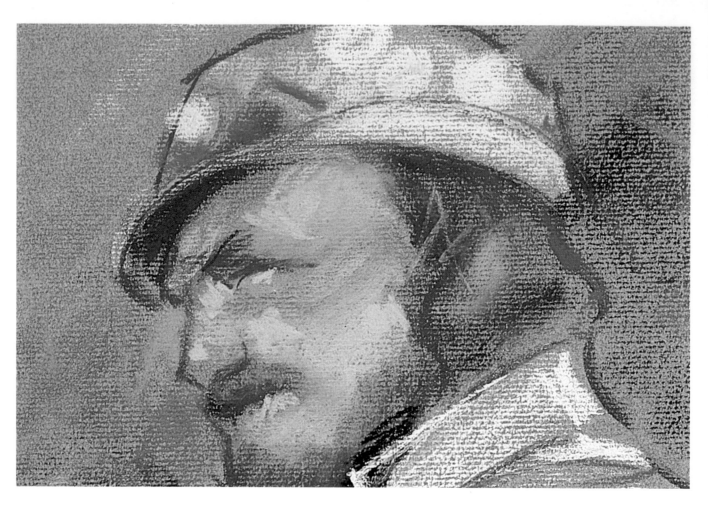

Detail, Stage 3. As the face was the focal point, it was now time to establish its supremacy over all other parts of the painting. I used generous amounts of madder brown 0 (339.9) and a little poppy red 6 (318.7) to model the features carefully to give the basis for the expression.

Stage 3

I repeated the light dusting operation to reduce contrasts and then re-evaluated the whole effect. I reinforced the shirt, fixed the shape of the collar, and indicated the badges on the hat. Cerulean 0 (570.9) and green gray 6 (619.3) were added to the background. Now that the overall strength of the painting was growing, I added some blacks to the trousers and accordion. Then, giving in to temptation, I allowed myself to use a little cobalt blue 0 (512.9) as a highlight on the face, being careful not to overdo it. Finally, I added the liveliest color of all, poppy red 6 (318.7), using it freely to mark in the sash and trimmings.

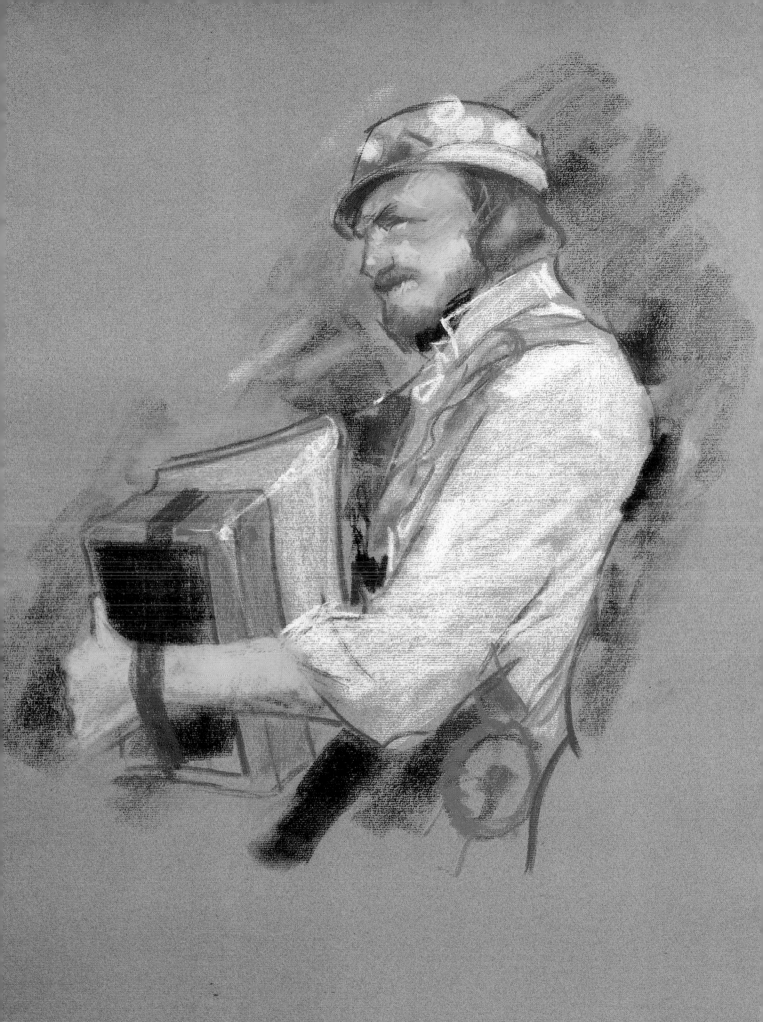

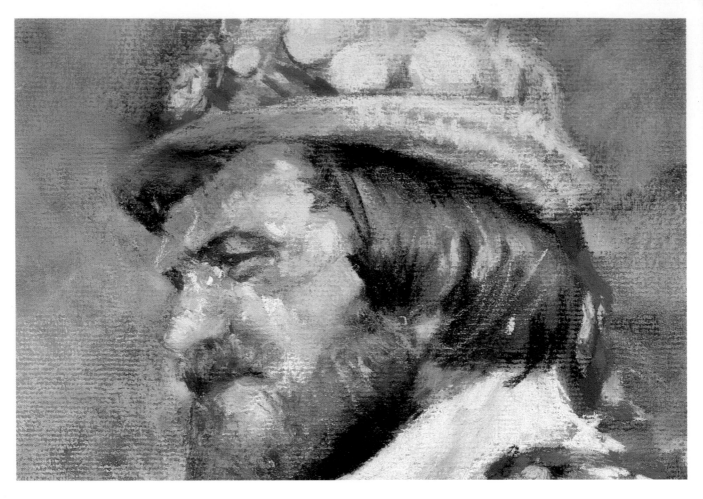

Detail, Stage 4. I experimented with a variety of colors in the face, rejecting most of them, and settling for tints made from grass green 1 (618.9), pansy violet 3 (546.7), mauve 2 (547.9), and cerulean 2 (570.8). I also faintly echoed some of these colors in the shirt after I had built up its whiteness and darkened the shadow areas.

Morris Man, 1980, Canson Ingres Tint 55, 19½″ × 25″ (50 × 65 cm).

Stage 4

As a counterpoint to the texture of the flesh and cotton fabrics, I decided that the accordion needed more mechanical detail, so I developed its shape and surfaces to quite a high degree of finish. This seemed to give the figure a much looser look and enhanced the convivial atmosphere I hoped to capture.

I always try to make the background as unobtrusive as possible, while ensuring that it has a subtle effect on strengthening the overall picture. Therefore, here I placed light tones behind dark edges and vice versa, keeping the edges fairly soft so the value changes would not be too abrupt. These wide, looping strokes of pastel may look casual, but they are never applied with abandon.

The rosette, sash, hat, and trimmings more or less painted themselves. The slightest touch of cadmium yellow 4 (201.5) in the hat band completed the light warm tones at the top of the painting in opposition to the cold dark tones at the bottom.

I now considered the painting finished and started to clean up, but after a quick glance at the painting, I returned to it and softened a few of the outer edges to increase the feeling of recession. Then, as I always do before declaring a painting completely finished, I arranged it over a picture in my living room and lived with it there for about a week. By then, any offending areas quickly become apparent.

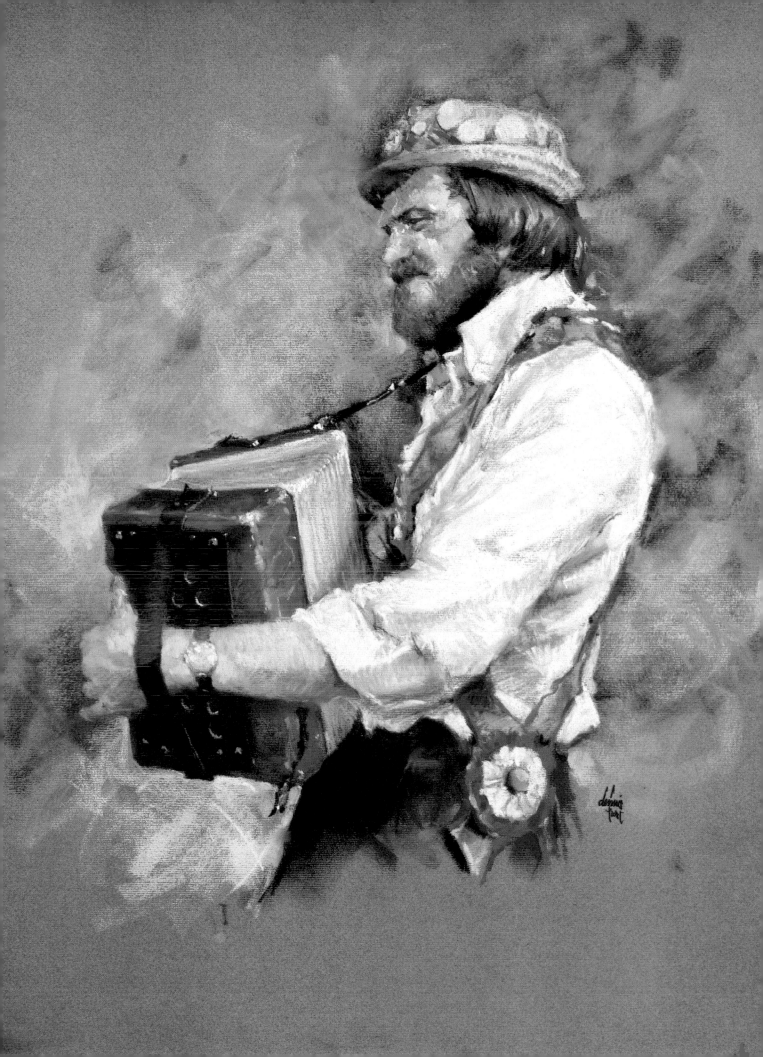

Dame Edith Evans

Economic use of pastel

I discovered a wonderful photograph of the late Dame Edith Evans in a magazine. Although it showed her seated in a garden, I thought I would try just a head-and-shoulders portrait, concentrating on capturing her personality. She was always one of my favorite actresses and the photograph managed to convey her poise. It was also a good record of her features; however, her expression reflected none of the vitality that gave her such a strong presence on stage. I decided to try to show this vitality in her eyes and with this aim clearly in mind, I began work with enthusiasm.

I worked slowly and carefully, making sure the features were correctly proportioned and then I built up the tones. There were no mistakes, but the shapes were tight and it just wasn't working! I took a break and tried to determine what was lacking. It seemed plain to me that the very same vitality I was so intent on conveying just wasn't there. I had mapped the features so carefully that even though they were unfinished, it was the overall interpretation that had misfired: The painting followed the photograph too closely, the form was overstated, and her flesh was too soft and rich in color. I had also blended the color more than was necessary and this, combined with the overuse of reds and browns, gave her a warm, friendly little-old-lady look which was not what I was after at all! It was now obvious that I should have used blues and grays instead of the warmer hues to make her seem more distant and give her an air of austerity. As it was now, the study was clearly a "painting from a photograph"—it was stilted and tight with no individuality of its own.

After having wasted an entire morning, I was inclined to give it up altogether and forget the whole project. However, I still had a vivid picture of her in my mind and as the main error in the original work seemed to be overindulgence in color and rubbing-in, I decided to give it another try. This time I would use cool colors and pastel strokes with economy and try to keep a loose, sketchy feel to the portrait.

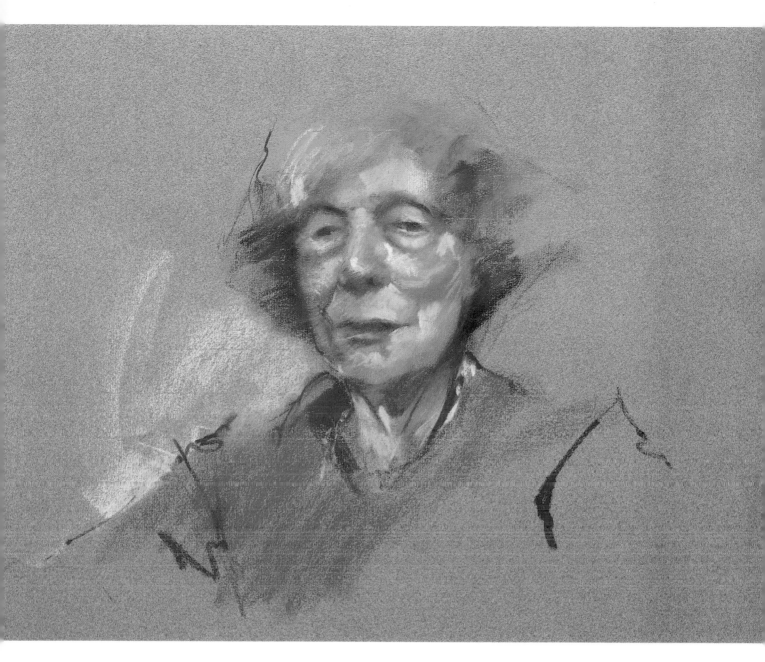

First Version
This was my first (unsuccessful) attempt to portray the late Dame Edith Evans. As you can see, the color is too warm overall—the inclusion of the red dress aggravated the situation—and the drawing lacks spontaneity and sparkle. I have also failed to capture her strong, dramatic presence.

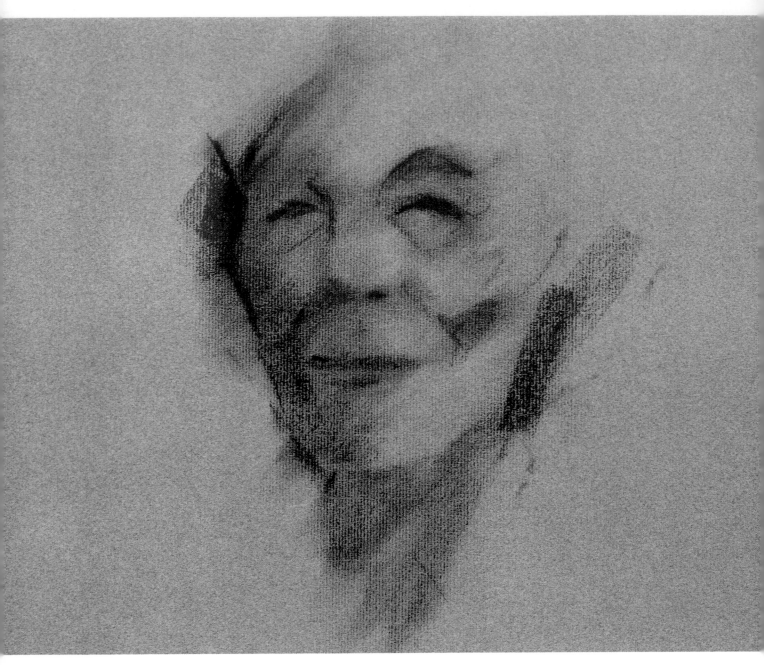

Stage 1

This time, determined to maintain a spartan approach, I mapped out the head using madder brown 8 (373.3) for the warm areas and blue gray 6 (727.5) for the cold dark colors. I softened these areas where necessary, trying to create short pastel statements rather than areas of constant tone. I made no attempt to draw the top of her head or her neck and shoulders, for I knew that the eyes and mouth were of paramount importance. If I got them right, the rest would follow.

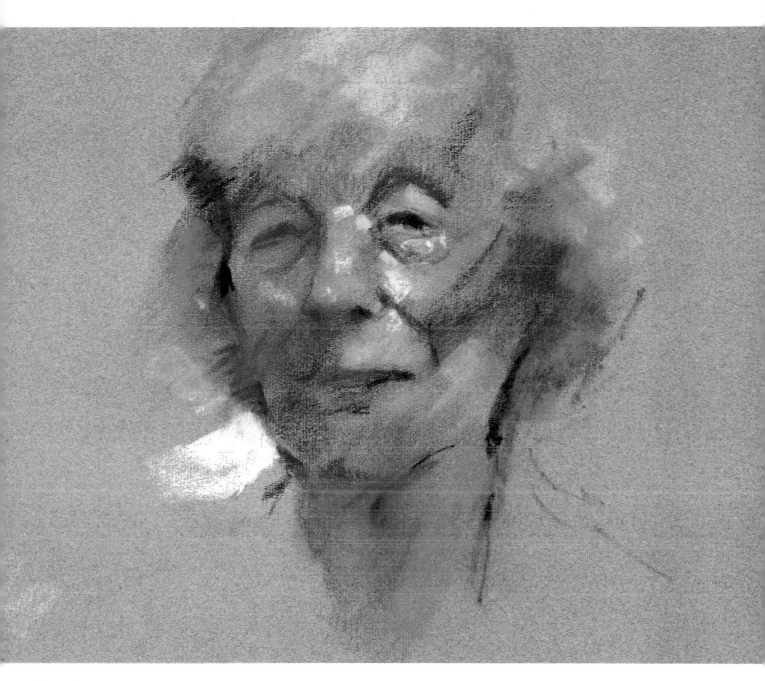

Stage 2

I used green gray 6 (619.3) to reinforce the darks on the edges of the cheeks and within the eye, nose, and mouth, then moved on to the light tones. I added cadmium yellow 1 (205.9) and cobalt blue 0 (512.9) to the cheeks and hair and placed a dash of poppy red 6 (318.7) along the edge of the eyelid. I resisted the temptation to rub-in any of these colors, but left them instead as hard-edged marks, hoping thus to capture the authority and presence that to me formed her essential character. I stroked a touch of madder brown 0 (339.9) across her left eyelid, then placed silver white (100.5) in the background at the lower left to balance the lighter tones in her face. It seemed to work, so I ventured on to the hair, using blue gray 4 (727.7) for a middle-value tone.

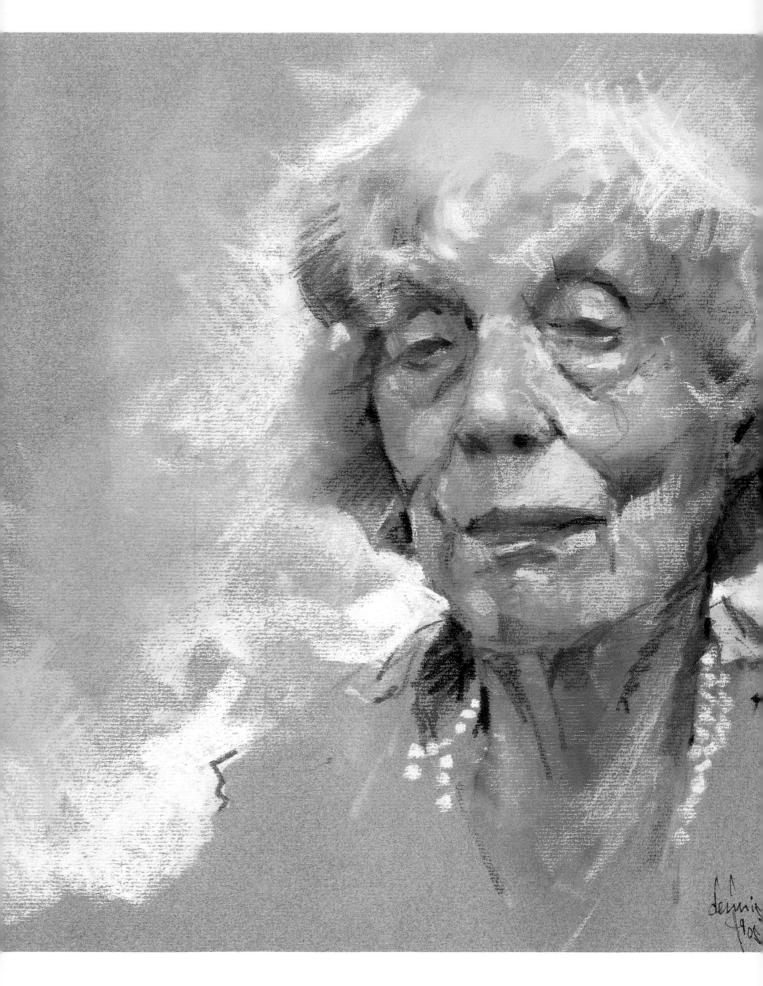

Stage 3

This was probably where I went wrong with my first attempt, for I had continued to add color at this stage when there was already enough on the paper. But this time I knew that the portrait only needed a careful adjustment of tone and a general cooling. I began work on the background and the head, adding light tones of silver white (100.5) and madder brown 0 (339.9) to the background to echo the flesh tones.

When I finished the face I saw that there was little left to do and that adding more pastel would destroy the luminosity. Working now to bring the rest of the portrait into balance, I increased the background area and then described the necklace as loosely as possible, making an effective tonal contrast against the background and barely suggesting the neck and upper chest. The necklace was the only light value in this entire area; everything else was described in low tones.

I decided that was enough. Although the portrait was little more than a sketch, it was much closer to my original idea than the first attempt. I had painted an impression rather than an accurate record and, above all, I was pleased with the looseness I had achieved. I strive for this elusive quality and find it difficult to capture but I think it exists here because there is little pastel on the paper, the pastel strokes are short and strong, and there is very little rubbing-in. All these things combine to suggest the pale skin and sharp, decisive features.

Dame Edith Evans, 1980, Canson Ingres Tint 55, 16″ × 19½″ (41 × 50 cm).

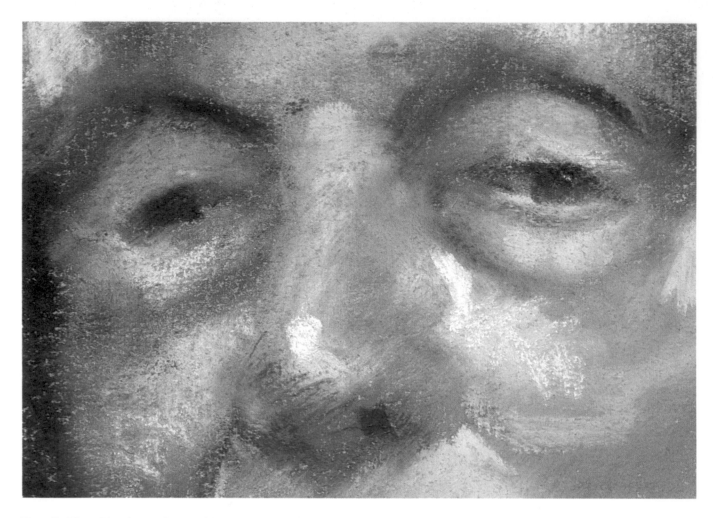

Detail, First Version. The problem with the first painting lay in the general overall interpretation, not in individual details. However, a look at this detail will serve to explain some of the general errors. First of all, the colors were blended too much, which gave her too soft and gentle an appearance. Then, there were too many reds and browns and their overall warmth and brightness also detracted from the commanding and intense presence I had hoped to portray.

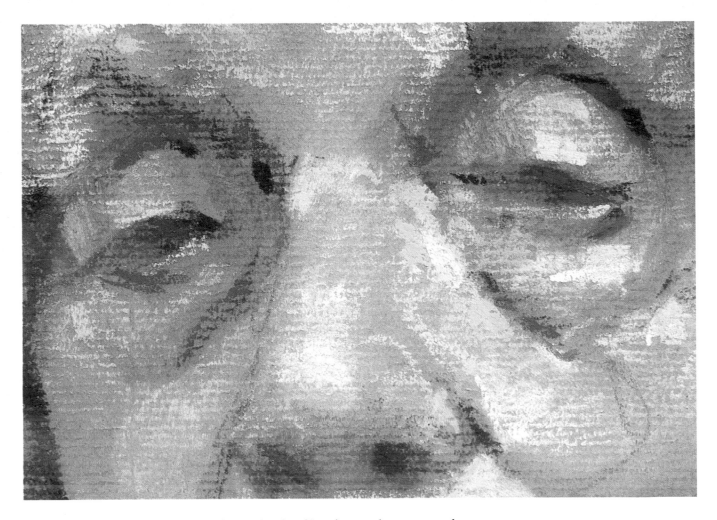

Detail, Stage 3. I lightened the left-hand side of her face and accentuated the highlights with cadmium yellow (205.9), cobalt blue 0 (512.9), and silver white (100.5).

Since I realized that emphasizing the sunken eyes and deep lines at each side of the upper lip would increase the impression of age, I worked in a light tone of madder brown 0 (339.9) on each eyelid, under her left eye, and on her left cheek to make the shadow above the eye sockets appear darker, and finally crosshatched it on the lower left-hand cheek. I then added grass green 1 (618.9) to the side of the nose, glazed it across the right side of the upper lip, and made one short stroke on the lower lip for the highlight. Most of these final touches were put in with pieces of pastel used on their side with short, heavy, decisive strokes.

By choosing cooler colors like silver white, bluish (madder) brown, and cobalt blue, and by using less intense colors like blue gray and green gray in the hair and face, I was able to decrease the overall warmth and tone down the color of the portrait. I also emphasized her advanced age and strengthened her features by deepening the hollows of the eyes and cheeks and darkening the lines at either side of her upper lip.

The Last Lap
Using background and atmosphere to create tension

Although there's nothing wrong with drawing posed models in a heated studio, it can be tedious and uninspiring unless it is interspersed with other types of sketching situations. So one clear day last spring, I decided to take my sketchbook to an athletics meeting and attempt to catch some really active figures and expressions. It turned out to be a great idea, for there I found road and track runners, jumpers, and vaulters—all good drawing material. I worked all afternoon, turning from one event to another and trying to catch some of the expressions and effort in the faces and figures. I was especially impressed by a group of tired runners that streamed past me at the end of a long road race, each one showing his own signs of exhaustion. Faces told of agonies in the body, clenched hands indicated tension, and tousled, wet hair demonstrated physical exertion.

Back in my studio, I examined my drawings and tried to piece together a plan for a painting of an exhausted runner. One lean figure in particular captured my imagination, and I decided to try to make his face show all the agonies of his body. I also planned to use a rough, overstated color scheme that would exaggerate these physical conditions.

Stage 1
I made a basic drawing in bistre Conté crayon to establish the action of the runner and catch him in mid-stride. I went over the outline of his hair, singlet, and shorts, making curved strokes with a half-inch (13 mm) stick of pastel on its side. This set up angular shapes and lines in juxtaposition to the smoother edges of his arm and legs—already the interplay between opposite shapes was working—and I set up a similar interplay of values by laying-in a few dark areas.

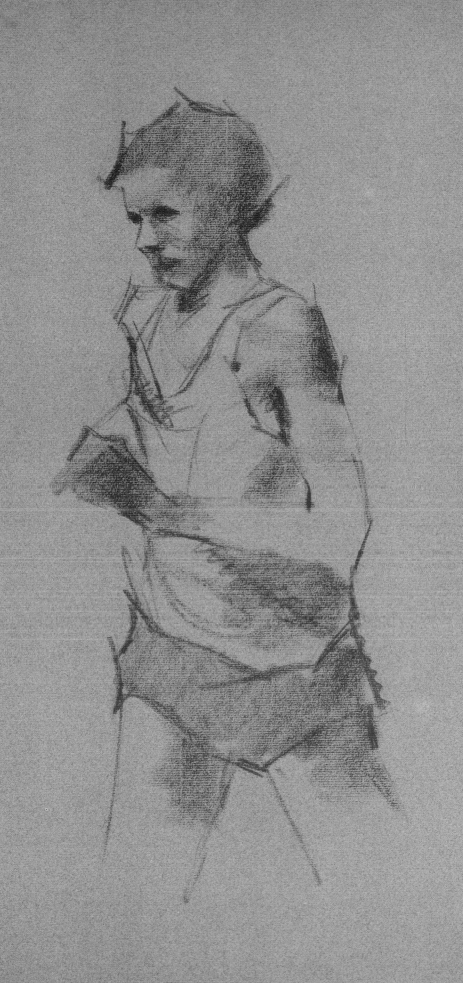

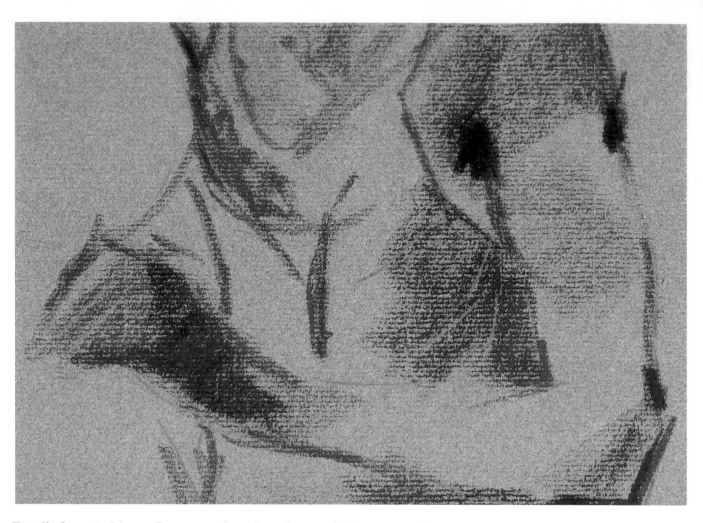

Detail, Stage 2. I kept all my pastel strokes short and vigorous so that there were no areas of calm anywhere at this stage. Had I wanted softer strokes, a little rubbing-in would have broken down the sharp contrasts between dark and light.

Stage 2
Now I worked in the tones vigorously, using Vandyke brown 8 (409.3) in the hair, madder brown 8 (373.3) in the heaviest flesh shadows, and blue gray 6 (727.5) for the shadows in the singlet and the flesh. As I wished this to be a very light-value painting, I needed to get all the darks down on paper as soon as possible.

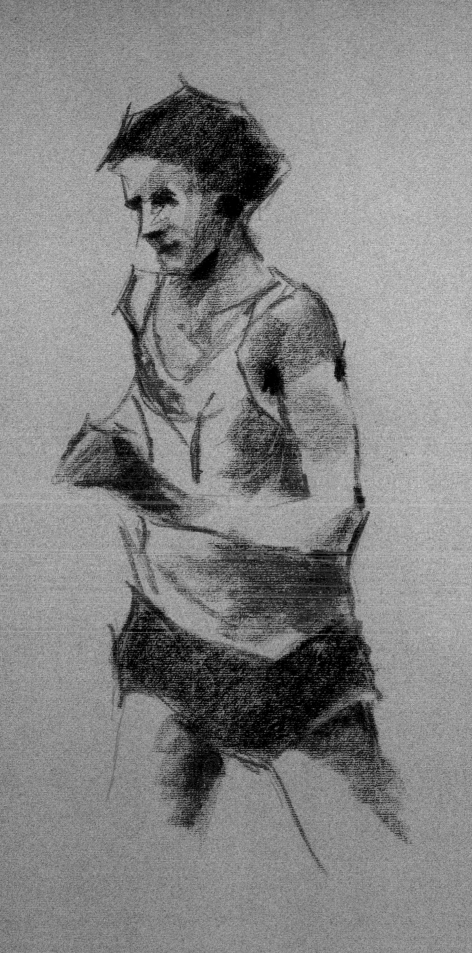

Detail, Stage 3. The light yellow around the hand makes the poppy red card appear brighter and the hand seem darker by contrast.

Stage 3

The painting had now reached what I call the "take-off point"— all the drawing and tonal values were established, and I was ready for the color. I applied madder brown 0 (339.9) to the flesh tones, white to the singlet, and poppy red 6 (318.7) to the card and some areas of dark flesh. Then I added dark color to the deeper tone areas: Vandyke brown 6 (717.3) to the hair and black to the shorts and stripe on the singlet. I purposely left each area of color looking crude and unworked, letting the rough strokes create their own tonal vibrations on the upper arm, shoulder, and thighs.

Next, I painted the background with broad marks made with long sticks of cadmium yellow 1 (205.9), cobalt blue 0 (512.9), and madder brown 0 (339.9) used on their sides. My intention here was to keep the tones very light and introduce vibrant color by opposing warms and cools, and darks and lights all around the tense figure. For example, the blue above the hair offsets the warm Vandyke brown below it, and the stroke of blue next to each thigh sets up a counterbalance between the cadmium yellow and madder brown in those areas. Judged alone, this stage looks extremely crude and bedraggled. But this was exactly the effect I wanted—later refinements would offset this roughness just enough.

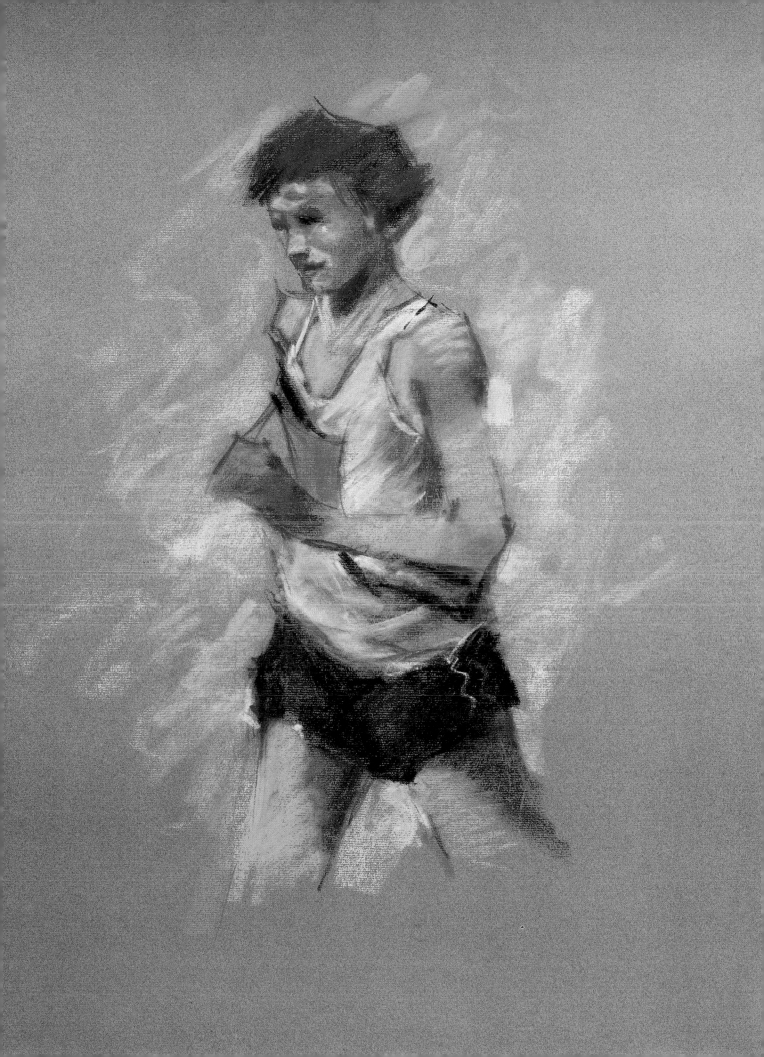

Detail, Stage 4. Because the figure, the singlet, and the background are all light I used changes of color rather than of value to differentiate between them, applying cadmium yellow 1 (205.9), cobalt blue 0 (512.9), and madder brown 0 (339.9) in rotation. If the singlet had been darker, I would have used darker colors in the background and have aimed for a subtler contrast in values and colors rather than the sharp change of colors I was forced to use here.

The Last Lap, 1980, Canson Ingres Tint 55, 19½″ × 25½ (50 × 64 cm).

Stage 4

I began to work up the flesh tones, rubbing-in some areas, leaving others rough, adding soft side strokes of pastel in some places and hard end-on marks elsewhere. I paid special attention to the hand and face, using grass green 1 (618.9), cobalt blue 0 and 2 (512.9 and .7), and Vandyke brown 6 (717.3) to model the forms there. I also worked more color into the background, breaking up the edges of my strokes with a two-inch (5 cm)-wide varnishing brush to keep the background subordinate to the figure.

This painting has no single focal point; I wanted the whole figure to be the object of attention and look tense all over. The eyes are dark and squinting, the mouth looks drawn and unnatural, and the clothes hang loose or flap about. All these details were pre-planned before I put pastel to paper and I've only slightly overstated them in order to exaggerate the overall stress and tension in the runner.

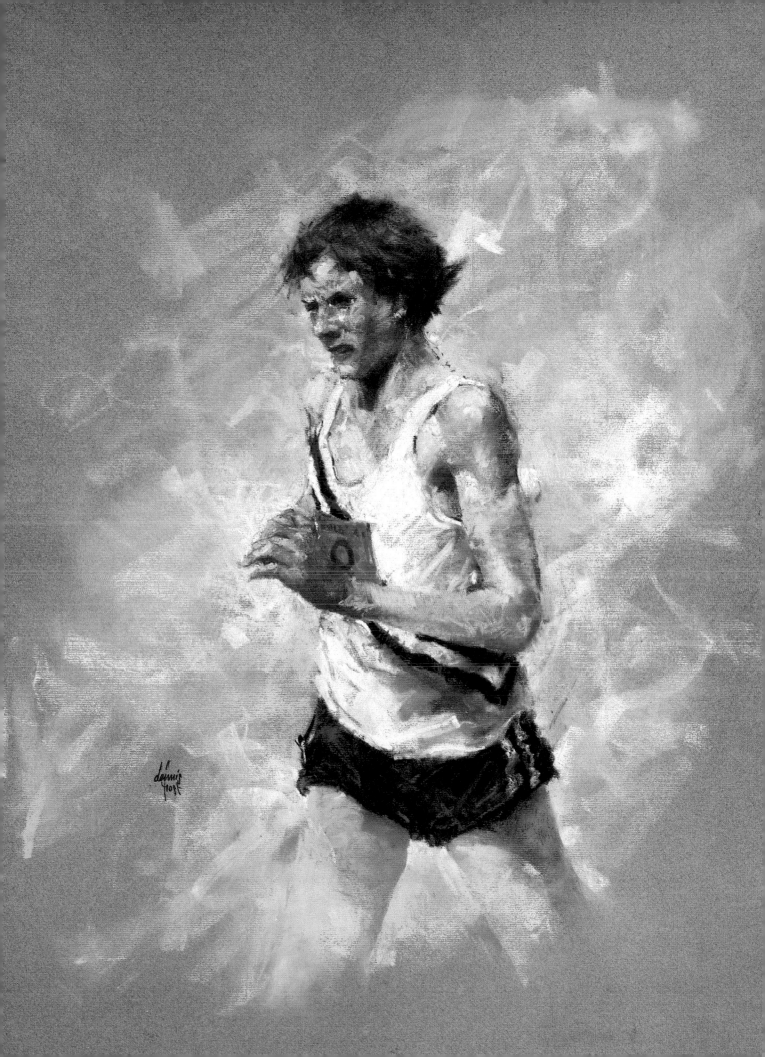

Allegro

A study of concentration and composure

This flautist made a wonderful subject and it was an exciting challenge to capture in pastel. There was no great problem with her overall pose, but the unnatural shape of her hands and mouth demanded careful scrutiny. The shape of her head was completely different, for while playing, her mouth was slightly open and her cheeks distended with air, causing her other features to appear flat.

The subject was a complicated arrangement of strong lines balanced with soft curves, tight drawing contrasted with loose impressions, and wide-ranging tones. Above all, I was convinced that nothing must dominate the face and its complete concentration. The conflicting shapes and tones here demanded a completely different treatment from that used for the Chelsea pensioner, where there were no props to arrange.

Stage 1
I decided to establish the two principal features (the head and the flute) in relation to each other and began by blocking in the figure loosely with bistre Conté crayon. I laid the tonal foundations of the face quickly with madder brown 0 (339.9), using madder brown 8 (373.3) for the darks and blue gray 4 (727.7) mixed with poppy red 6 (318.7) for the shadows. In contrast to the softly drawn facial features, I used a ruler to draw the sharp outline of the flute, taking care to place it so that it provided a firm diagonal direction.

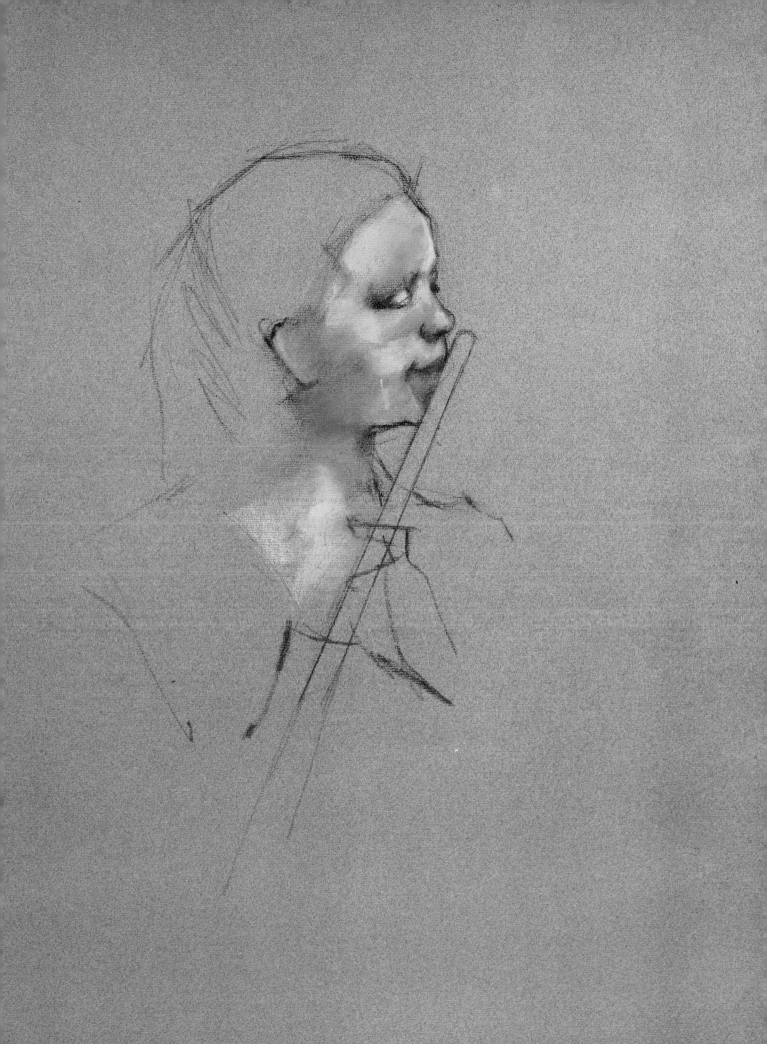

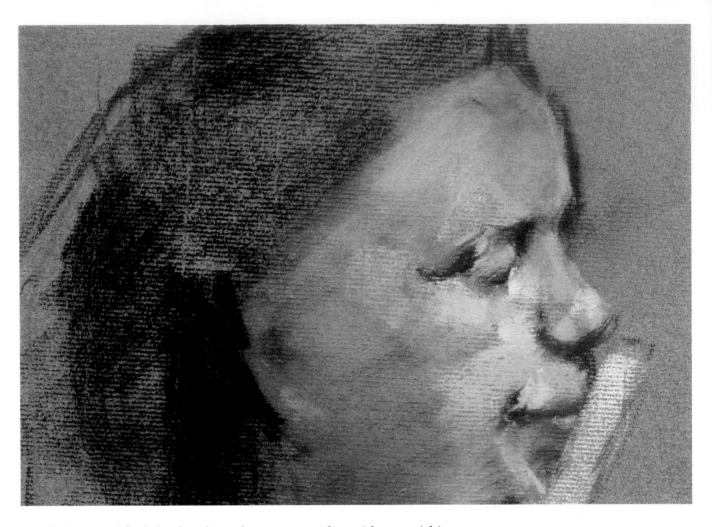

Detail, Stage 2. I find that brushing the tones together with a varnishing brush is a more sensitive method of blending color than rubbing-in, which encourages a thick build-up of pastel on paper.

Stage 2
I wanted to achieve a warm dark tone for the hair, so I selected Vandyke brown 6 (717.3) with overtones of Vandyke brown 8 (409.3). I used white lightly on the dress and flute, and introduced a touch of cobalt blue 0 (512.9) and white into the face. Once I placed the hands with madder brown 0 (339.9), I softened all the tones with a varnishing brush.

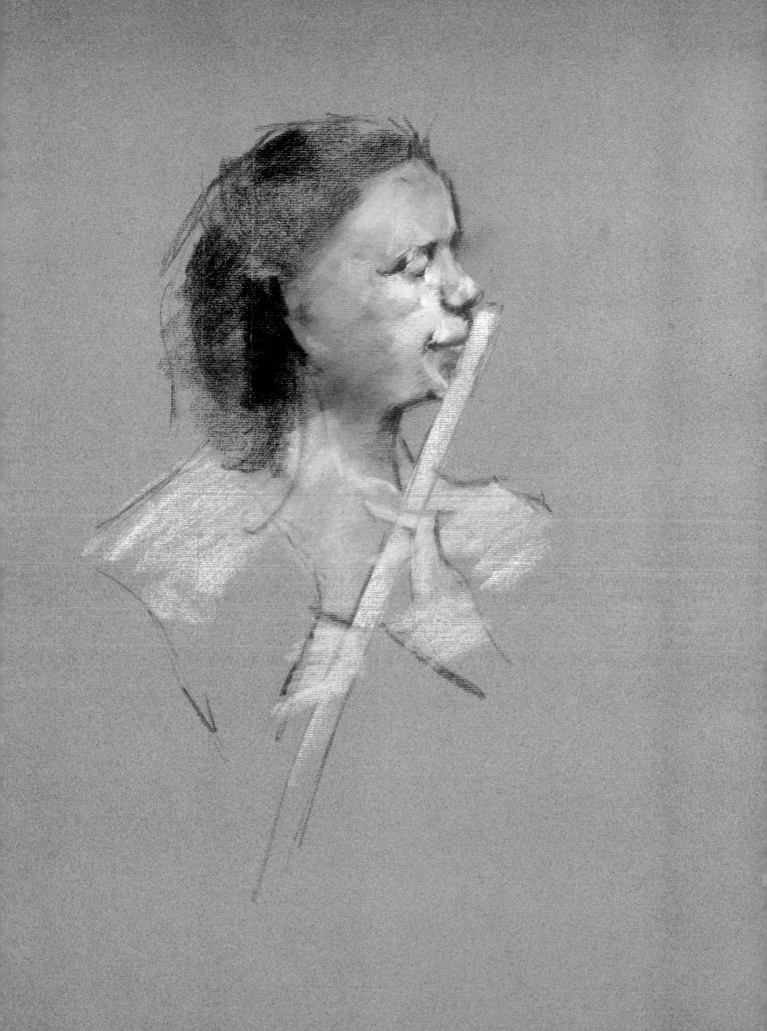

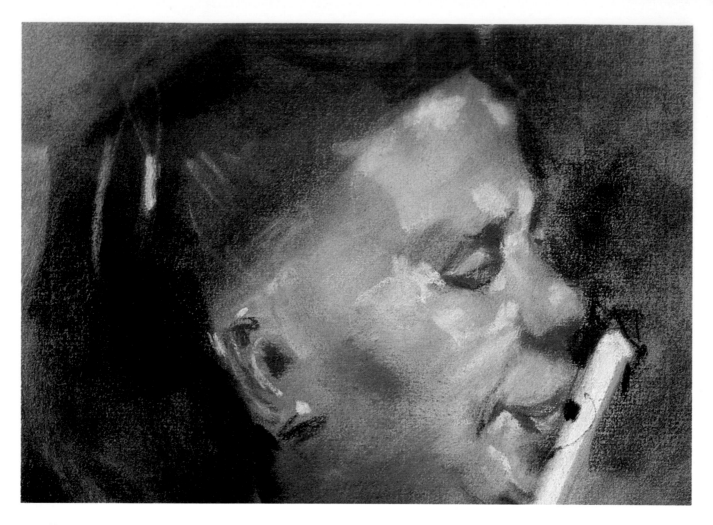

Detail, Stage 3. I touched in a little cerulean 2 (570.8), pansy violet (541.7) at the back of the cheek, and added grass green 1 (618.9) at the corner of the eye and mouth.

Stage 3

Was I being too cautious? Up to this point, I had only a rough impression of the composition and treatment in my mind, but it now became clear that I must resolve all the compositional and tonal problems; a slow, labored approach usually makes for a dull, tight drawing.

I added dark hair with wide strokes of black and then put in the other large area of dark tone, the music stand. I kept its dark tones cold by using black, pansy violet 3 (546.7), blue gray 6 (727.5), and cobalt blue 2 (512.7). Returning to the lighter tones, I used cadmium yellow 1 (205.9) for the dress and short sharp strokes of madder brown 0 (339.9) for the highlights of the face. I also strengthened the hands and flute with madder brown 8 (373.3) and white, respectively. Finally, I chose green gray 6 (619.3) and cobalt blue 2 (512.7) to produce a background base; I had completely neglected this area until now. The painting needed only a light brushing to reduce sharp tonal contrasts in some places. However, I still had to capture the muscle contours around the mouth and in the neck. These minute details would give the impression of intense concentration needed to make this portrait convincing. I relaxed for a moment and considered how I was to achieve this.

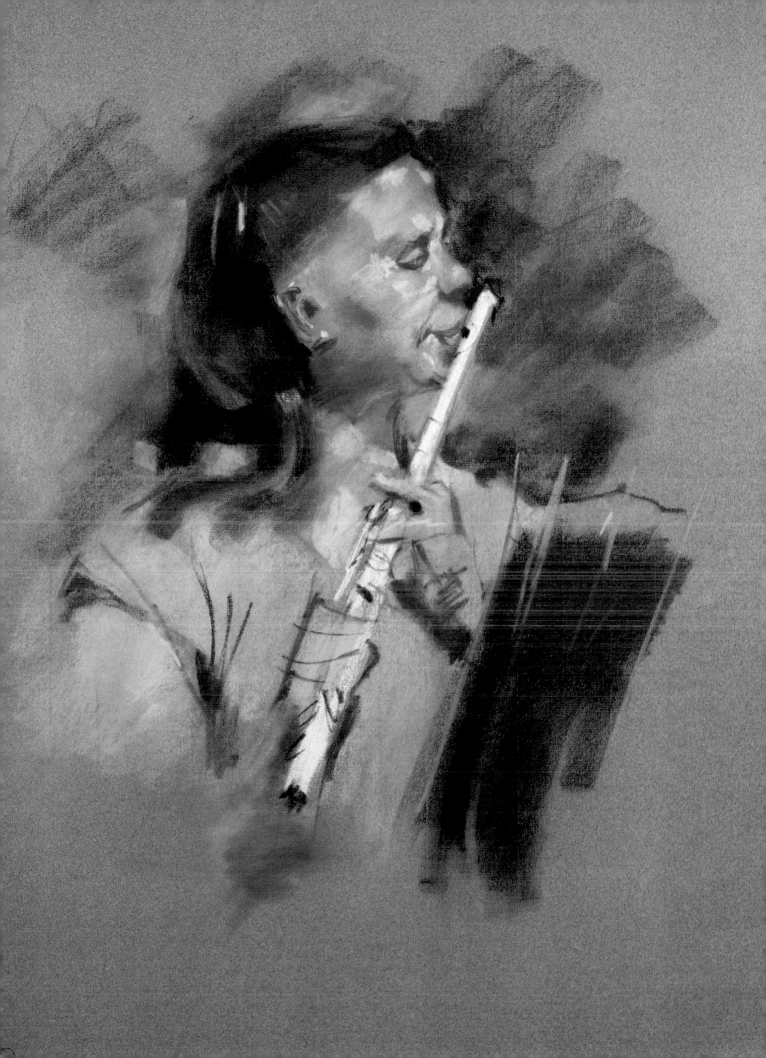

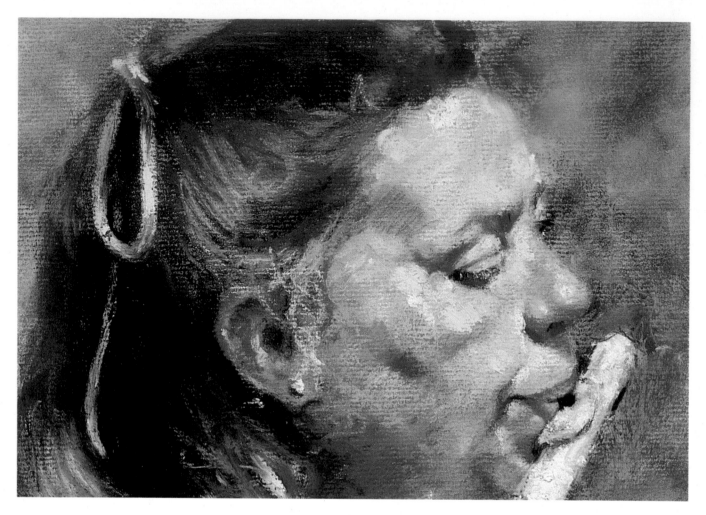

Detail, Stage 4. I spent much time on the flesh tones, adding color and leaving it raw, or rubbing it in and almost completely hiding its true identity. One problem was that it was impossible to show the contours of the small muscles around the mouth and hands without using a tight drawing technique and thus losing the looseness of the overall approach. I solved this by using small patches of white and other light tones to create taut skin and an appearance of strained concentration.

Allegro, October 1980, Canson Ingres Tint 55, 19″ × 23″ (48 × 58 cm).

Stage 4

It looks as if a lot of drawing was done here, but that is only because strong, thick strokes contrast with the gentle values laid earlier.

The flute appears to have drawn carefully; in fact it was made from a mass of broken shapes and values that create the illusion of keys, rods, and stops. The clothes pegs at the top of the music stand are so loosely drawn as to be almost unrecognizable—their function in this portrait is to provide a relaxed, natural contrast to the tight, shiny form of the flute. Tiny dots of seemingly unrelated colors like pansy violet 3 (546.7), poppy red 6 (318.7), cadmium yellow 4 (201.5), and grass green 1 (618.9) were arranged throughout the picture to develop a relationship between the subjects. These specks of color harmonized so well that I repeated the effect as I laid in a simple background of cobalt blue 2 (512.7) and white over a heavily brushed surface, softening the dark tones laid down in Stage 3. A single white highlight on the top of the forehead finished the face and made it the focal highlight I had intended it to be.

Her left shoulder was made prominent by producing a hard line and a strong contrast between her dress and the background, leading the eye from the top of the music stand to the body. On the other hand, the flautist's right shoulder fades gently into the background preventing the eye from being distracted from the central action.

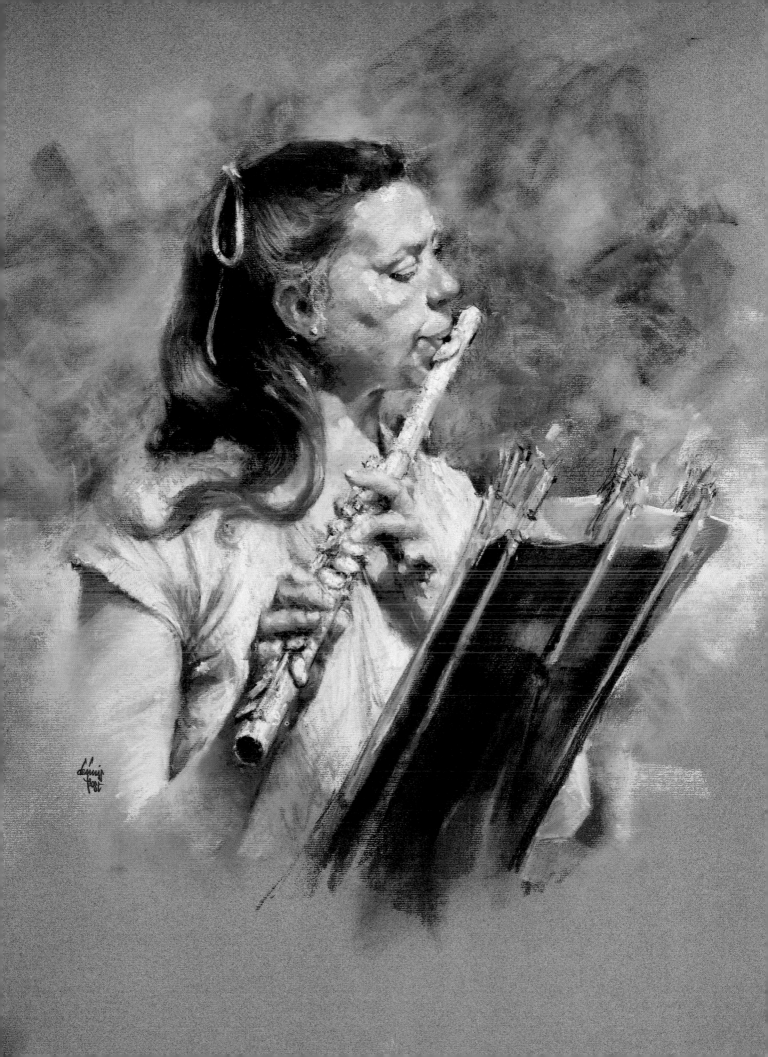

Gallery

This portrait is the complete antithesis of the one of the patrolmen on page 124-5. Here is a friendly, unaggressive old man, who represents no threat to anyone and stands simply as a monument to respectable old age. He lives in a small village, where he has probably spent his whole life. His clothes are old and comfortable and his hat a relic of another era. His snow-white walrus moustache hides his missing teeth and its droop echoes the downward slant of his shoulders and his slight stoop.

I painted him in warm colors, using a lot of sanguine bistre Conté crayon on his neck, ear, and a little below his mouth and around his eyes to give his countenance a weatherbeaten look. The warm stripes on his sweater were applied boldly and loosely and there are a few cold tones in his bright, white crumpled shirt. The background is quite dark, but without any areas of cold color—even the light blue tones there are on the warm side.

This is a simple pleasing study. I was tempted to exaggerate his bolder features and make him a really eccentric character, but I resisted this in favor of portraying him exactly has he was.

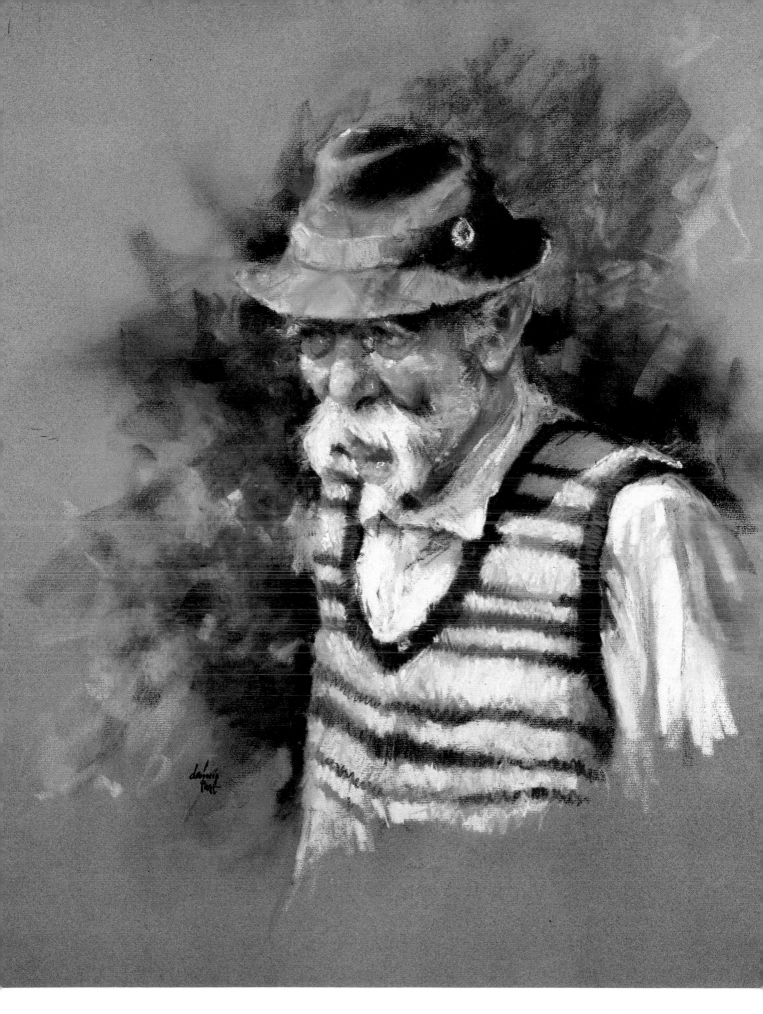

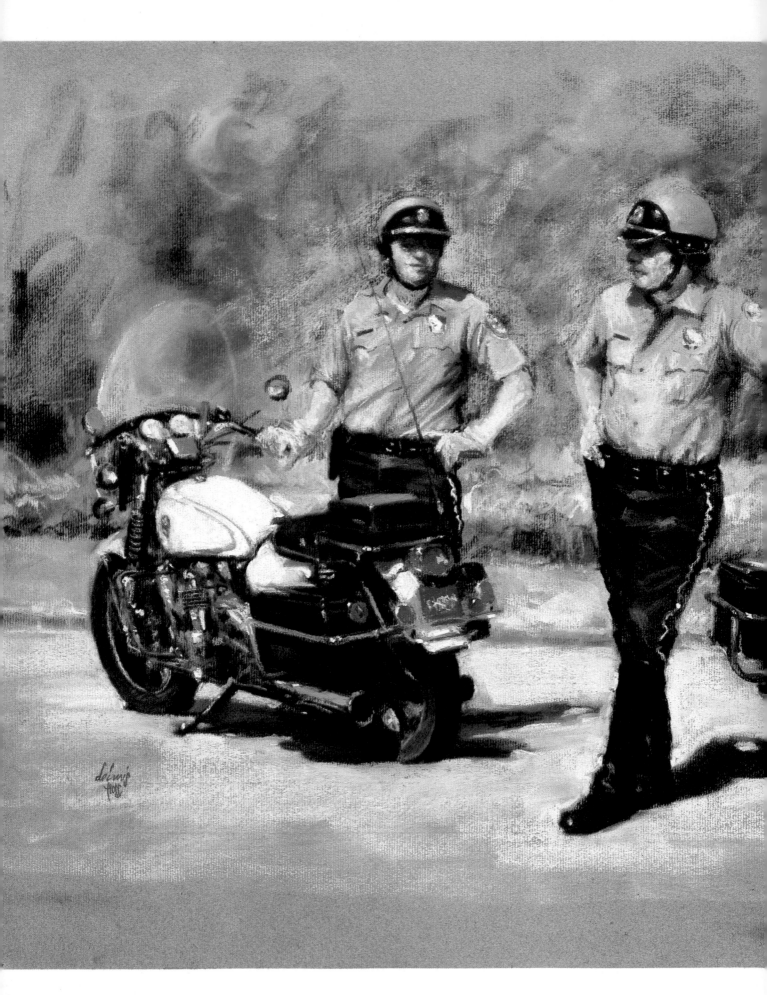

The Highway Patrolmen, October 1980, Canson Ingres Tint 55, 19" × 23" (48 × 58 cm).

My aim here was to try and capture a collective attitude rather than express individual personalities—both faces have a bland expression and I took care not to let any particular features give life to their character. I made this painting from a sharp photograph that clearly showed the intricate workings of the bikes and details of the uniforms. I planned a gentle, woodland background and a nondescript piece of road as a foil to the aggressive steel and chrome and stern authority the patrolman symbolized.

The only really warm colors in the painting are the red lights. Everything else is painted in a cool or cold color, lending an unfriendly air to the subjects, intensified by the fact that their eyes are hidden behind goggles. The background is composed of light strokes of natural colors, leaving much of the gray paper exposed.

I was quite pleased with this painting because it did manage to convey a mood, and the bikes, which were difficult to draw, worked well. If I had the time (the cry of most painters), I would like to do more such paintings with a theme, for they are a real test of ingenuity in deciding how to communicate an objective idea, as opposed to a straight subjective portrait.

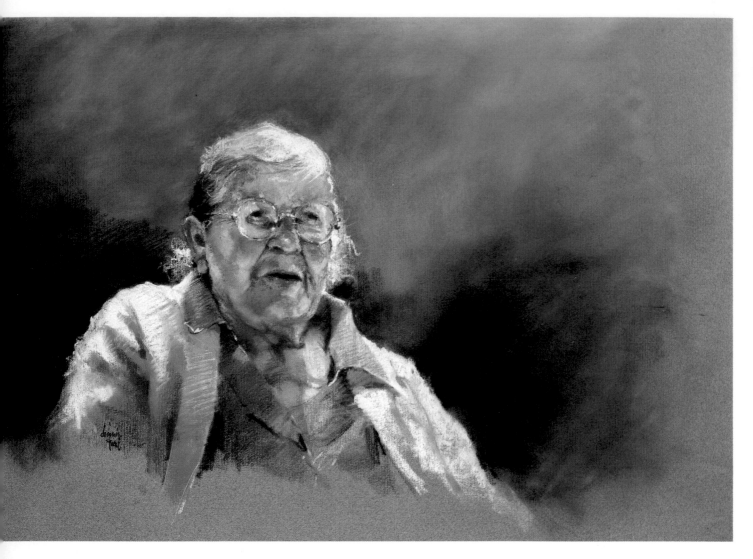

My aim here was to radiate warmth—not only that of the sunshine, but also of the woman's genial, relaxed contentment. The lady is lit from above and behind and the effect of this strong light is greatly enhanced by the interplay of the two patches of green—the woman's dress and the background color—that produce a strong counterpoint.

Although there is a similarity in subject between this painting and that of the sick woman in the dressing gown on page 130, I used a more vigorous treatment here because this woman is healthier and more ruddy. I also used the edge of the pastel more here to produce a harsher drawing. The sharp strokes and strong contrasts produce a striking study.

Sitting in the Autumn Sunshine, October 1980, Canson Ingres Tint 55, 19″ × 23″ (48 × 58 cm).

The Morning Stroll, Autumn 1980, Canson Ingres Tint 55, 19″ × 23″ (48 × 58 cm).

In this study of an old man walking, the posture was all-important. There are few soft edges on the back of his jacket, so the line of his spine is quite pronounced. The sharp treatment of the coat, achieved by using the edge of the pastel in a linear manner, and the heavily pressured broad strokes that form the background, were made in a deliberate attempt to steal the limelight from the head and make it appear softer.

The whole study is very pale, conveying a sad and slightly solemn old man. His head is almost turned away, there are few details on the face, and his personality is very understated. The warm yellow background tones provide the only sunny patches.

When the painting was finished and framed, I placed the head very close to the top of the mount, suggesting that he was a tall person. By making a composition where the subject is walking away from the viewer, I created a little mystery to his character and also conveyed the feeling of his solitude and his turning away from other people.

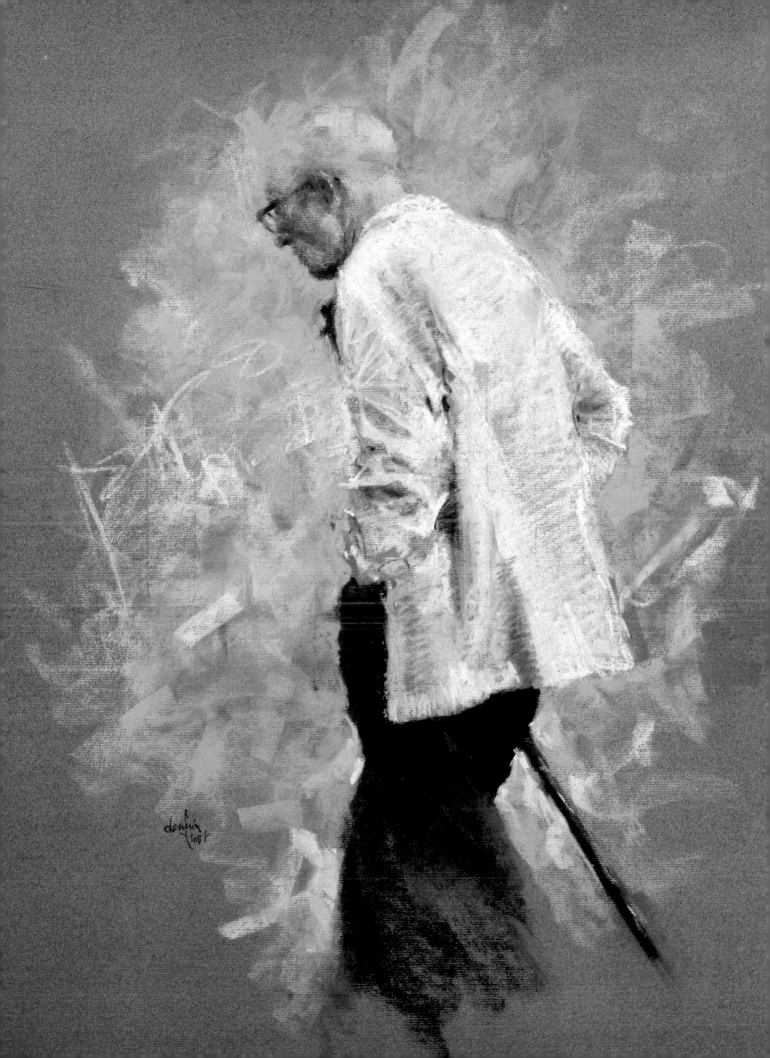

The Tinker, Spring 1980, Canson
Ingres Tint 55, 19″ × 23″ (48 × 58
cm).

This pose made an attractive triangular composition.
Since the man was looking away, his face was slightly
less than in profile, and so I was presented with the
problem of portraying his mischievous character and
scruffy appearance without being able to show it in
his eyes or mouth. But the cheeky angle of the hat
and his relaxed, gypsy-like style of dress gave many
clues.

The complicated twining of his fingers was difficult
to paint. Too careful a drawing would have made
them the focal point of the painting, so I had to
construct them carefully, and then obliterate parts of
their outline with loose, sketchy color to match the
style of the rest of the painting.

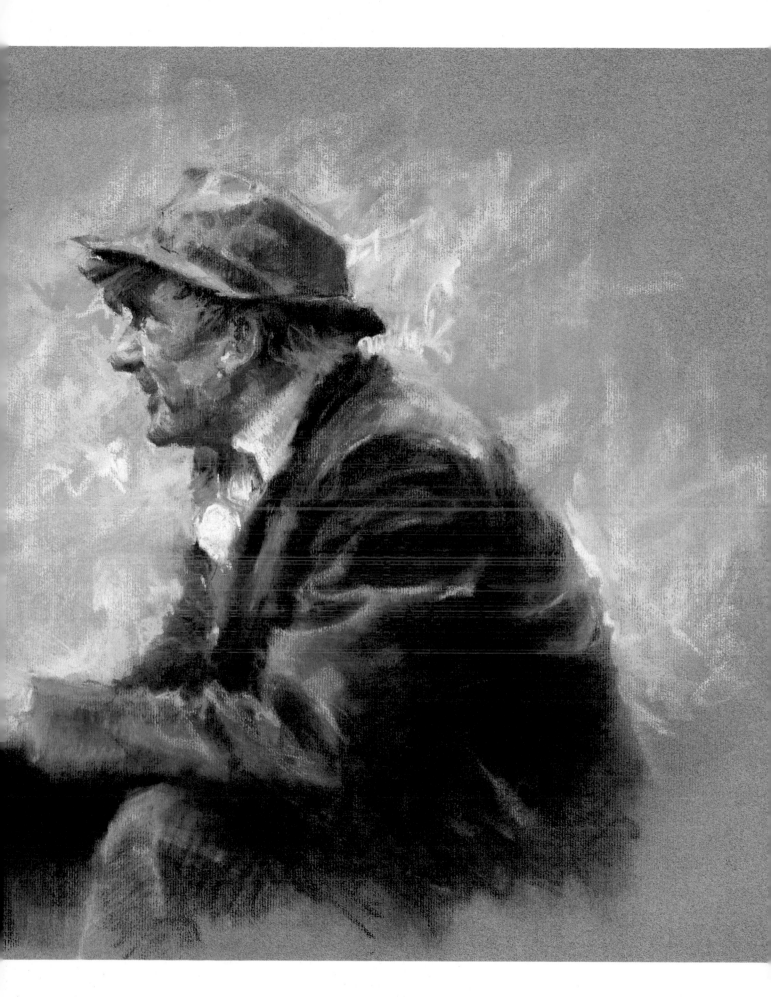

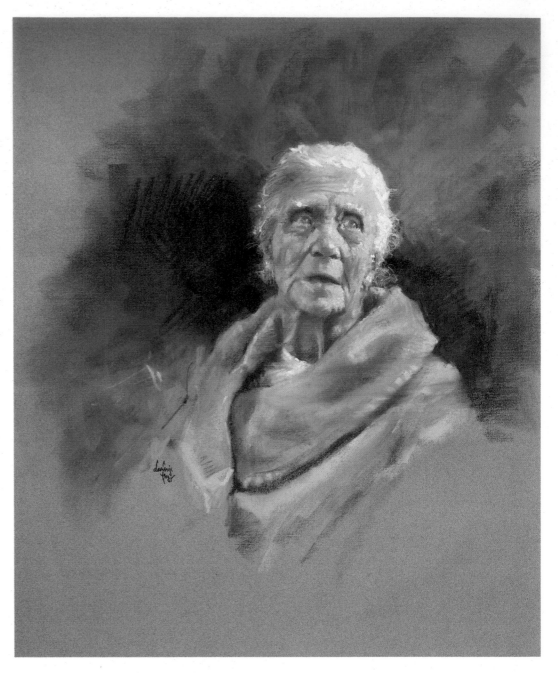

The Warm Dressing Gown, January 1981, Canson Ingres Tint 55, 19″ × 23″ (48 × 58 cm).

This old lady was spending her last days in a hospital for the terminally ill. She was never well enough to dress and could manage to leave her bed for just a few hours each day, wrapped in a large dressing gown that quite dwarfed her frail figure. I wanted to convey the fear and anguish of a dying woman for whom living had ceased to give pleasure and who had not the strength to cope with the thought of death.

Since I wished to inspire sympathy for this woman in my painting, I surrounded her with a range of cool, gray-based colors to give her an ashen appearance. There is no sign of the healthy, flushed weatherbeaten quality of the old man of Hunston (page 123). Here, the warm reds in her face are accentuated by the cool colors in her flesh. This is especially true of the reds of her sunken eyelids, where the irises are a washed-out blue and the dark pastel along the top edge of the eye sockets enhances their sunken, wasted appearance. Her hair is thin, white, and cut close to her head, exposing a pallid forehead.

It would have been a mistake to use strong contrasts of tone or color here, as these would have added too much vigour to a still, serene portrait. The painting created a strong impression of the old woman's plight, one that left an image in my mind long after I had finished it. Sadly, the old lady died two months later.

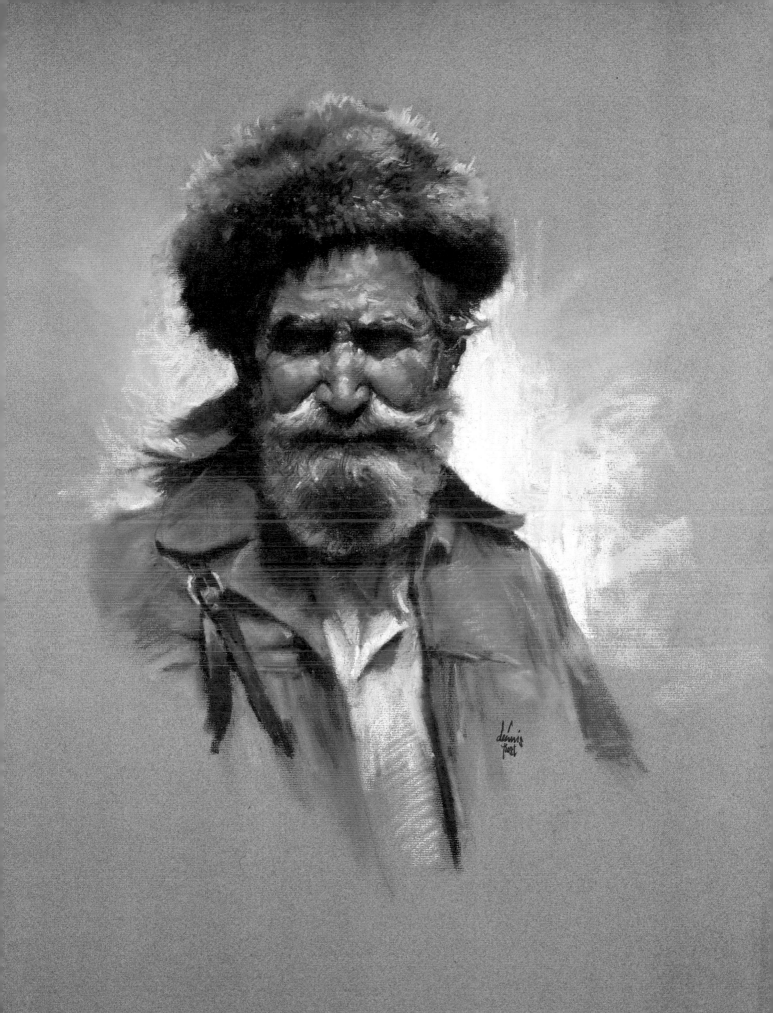

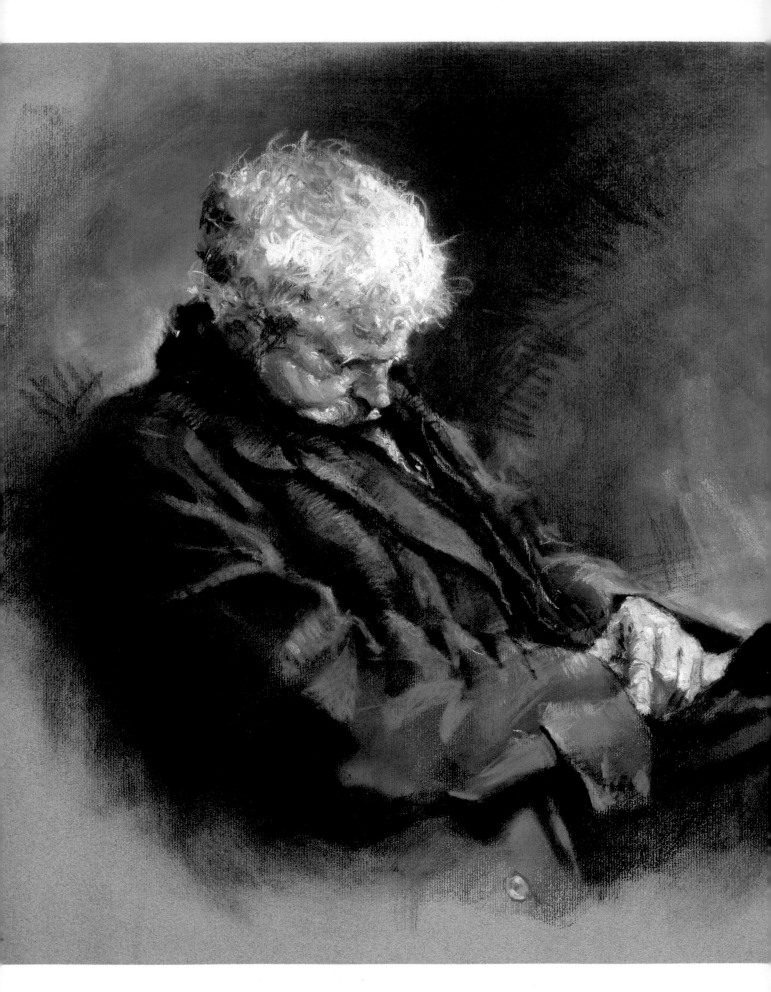

(Preceding page)

Prospector from Santa Cruz, October 1980, Canson Ingres Tint, 55, 19″ × 23″ (48 × 58 cm).

I saw this face in a crowd watching a carnival. What immediately struck my attention was the juxtaposition of textures: buckskin, hide, conskin, beard, and weathered skin. Juggling five different textures posed a real challenge and I was aware that each needed to be portrayed with conviction if the painting was to succeed. Pastel has a tremendous advantage over other media when painting textures. It is capable of describing an entire range of the hardest and softest materials through variations in pressure alone.

The leather thong that crosses his chest plays a strong part in the composition by providing a linear form in a painting of areas of confirmed texture. Without it, the other textural masses might have appeared too similar in nature and too static.

Man of the Road, December 1980, Canson Ingres Tint 55, 19″ × 23″ (48 × 58 cm).

In large cities, there are many desolate people who are down on their luck and live on the street with their belongings in a bag at their side. This man was asleep in a doorway—a still subject for a drawing. I hope I am not thought to be uncaring if I say that I often draw tramps because their acute degradation is quite dramatic.

I decided to make a somber, dark-colored study to enhance the utter hopelessness of the sleeping figure. My first attempt is shown on page 74. I decided that this composition was too upright for the subject and that the man would be portrayed better in a more prostrate position.

During the early stages of this painting, the major problem was posed by the placement of his head. Because of the pose, it was slightly foreshortened, and because his face was sunken into his chest, the features were distorted. However, I was reasonably content with the result shown here. His tousled white hair contrasts well in texture and value with the dark background, and his hands and face strike exactly the pose I was hoping to paint.

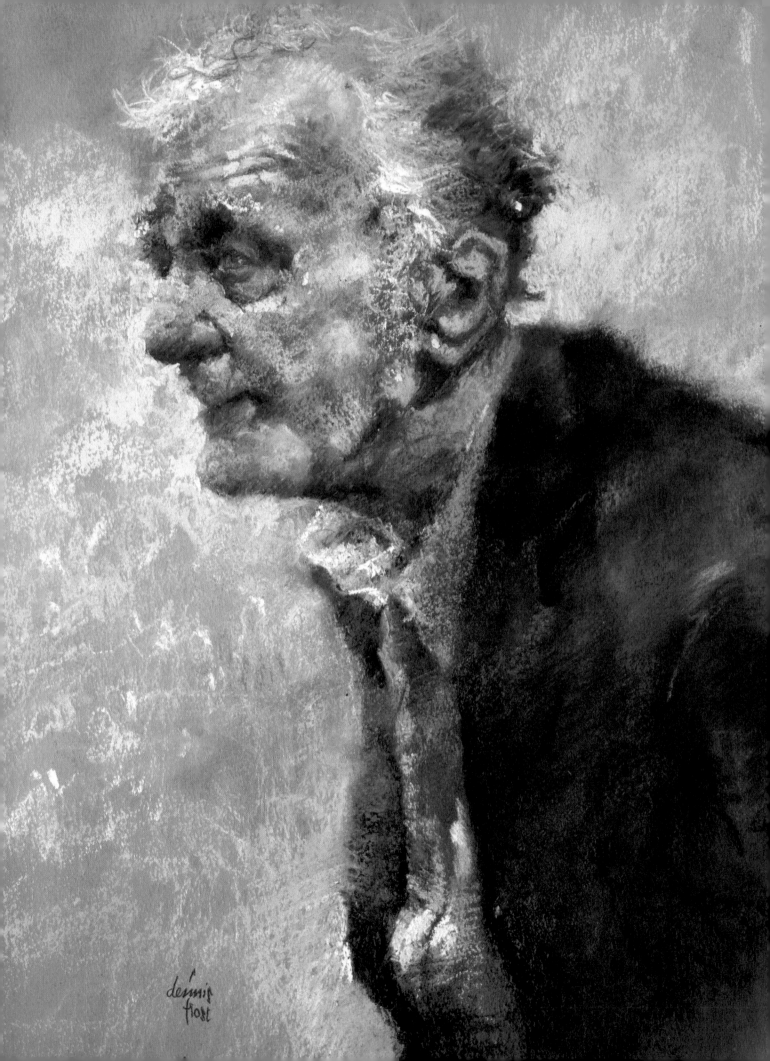

Appendices

The Widower, Winter 1980, Canson Ingres Tint 55, 19″ × 23″ (48 × 58 cm).

The Saunders & Bockingford 1981 International Artists in Watercolor Competition, sponsored by the Inveresk Paper Company, had a most unusual stipulation on the entry form. Although it was primarily a watercolor competition, provided the artist used the sponsor's paper, pastel works could also be entered and would be judged separately, a must unusual circumstance. The competition attracted some 2,500 entries from all over the world. This painting, on Saunders rough watercolor paper, was produced especially for the competition and was awarded first prize in the pastel category.

The paper was first given a flat wash of gouache, a media well-suited to the paper's granulated texture. When it dried, I applied the pastel. The watercolor paper was ideal for this subject, since its rough texture discouraged any tendency to apply the pastel in a smooth or delicate manner. To suggest the man's neglected and unkempt appearance, the outline of the figure was completely broken, and the bent stance also added to the feeling of despair I was trying to create. The hard, vigorous strokes of pastel in the hair also helped to emphasize the unkempt look of a man who no longer felt the need to keep up appearances.

Rowney-Rembrandt Color Equivalents

This chart translates specific colors from the Rowney brand of soft artists' pastels (available in Great Britain) to their equivalent hue in the Rembrandt brand of soft pastels (made by Talens and available in the United States). Rowney gives each color a name and adds a tint number to it—with 0 being the lightest value and 8 the darkest. Although the colors of the two brands do not match exactly, they are as near as possible within the manufacturers' ranges.

Chart No.	Rowney tint	Rembrandt tint
1	Cadmium yellow 1	205.9
2	Lemon yellow 2	205.7
3	Lemon yellow 4	205.5
4	Yellow ochre 2	202.7
5	Naples yellow 2	202.9
6	Cadmium yellow 4	201.5
7	Green gray 6	619.3
8	Green gray 4	618.3
9	Sap green 5	201.3
10	Viridian 3	657.7
11	Grass green 4	618.5
12	Grass green 1	618.9
13	Cerulean 0	570.9
14	Cobalt blue 0	512.9
15	Cobalt blue 2	512.7
16	Mauve 2	547.9
17	Indigo 1	506.9
18	French ultramarine 6	506.7
19	Vandyke brown 8	409.3
20	Vandyke brown 6	717.3
21	Silver white	100.5
22	Lamp black	700.5
23	Blue gray 6	727.5
24	Blue gray 4	727.7
25	Madder brown 0	339.9
26	Red gray 2	371.9
27	Pansy violet 3	546.7
28	Poppy red 6	318.7
29	Madder brown 8	373.3
30	Cerulean 2	570.8

Complexion Colors

Apart from the comparatively slight variations in skin color and value found among people of the same origin, there is a very marked difference between the flesh colors of the black and white races. Painting a wide range of flesh tones requires quite a varied palette and possibly also a different paper color, one that will complement the skin.

The color of the lighting also influences a painting. In fact, the first time you see a painting you produced under artificial light presented in daylight, you will probably be disappointed. The flesh will appear much too red (or too warm in general) and rather unnatural. To lessen this problem, I have equipped my studio with a fluorescent strip light that is manufactured to give a fair imitation of daylight. It is placed so that it lights my work from the same direction as the daylight that comes through my window.

This chart indicates the colors that can be used in painting a white person. In fact, the illustration on the facing page was completed with these tints. The chart consists basically of sanguine Conté crayon and madder brown 0 (339.9), blended together for an overall flesh color. The remaining colors were overpainted to suggest shadows and highlights.

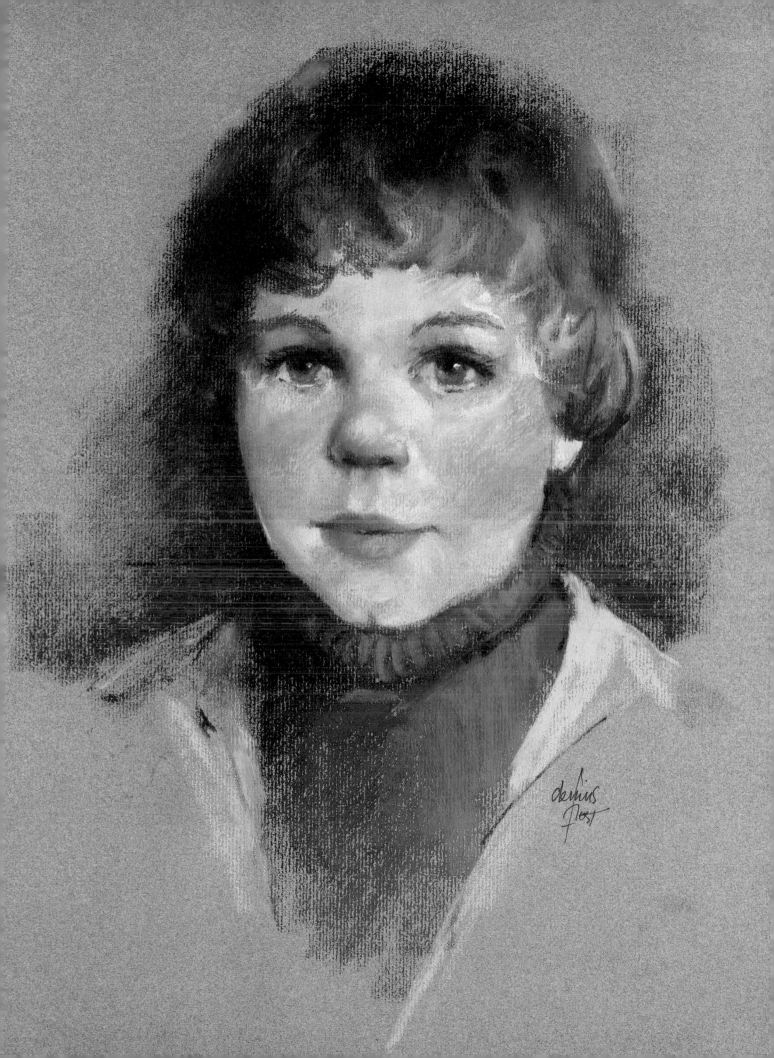

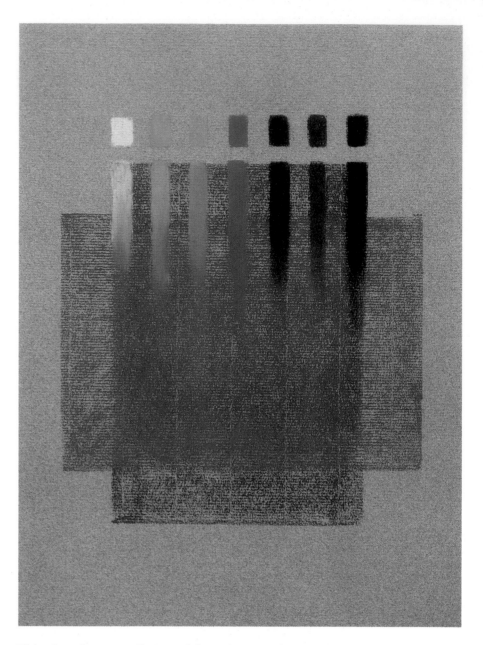

This chart is a compilation of the colors used in painting the complexion of the black man. The basic flesh color is a blend of sanguine and bistre Conté crayon. This portrait was made with the same nine pastels and the same arrangement of paper as in the chart at left. I tried to apply the pastel lightly so the color of the paper would influence the pastelled result. As you can see, the cream paper is especially sympathetic to a fair complexion because its natural color harmonizes with the flesh tones. The gray paper is also well suited to flesh tones, with the paper expressing a middle-value shadow color. But the range of values that show up on the green paper is limited. The paper color is only able to express the darkest shadows and would probably have to be well covered with pastel before it could contribute to a successful portrait.

Selecting Paper Color

The choice of a suitable paper color for your painting is, of course, entirely dependent on the subject. However, as a general rule, I avoid strong colors and opt for a middle-value paper with a quiet neutral color, usually a blue gray. Then I can plan a general palette that will work for most portraits. But there are occasions when a different arrangement is necessary, and so it is useful to know how the hues that can be used with success on one color paper, will react when used on another. Obviously, dark-colored pastels will be less dramatic on dark paper than they would be on a light one and vice versa. That is why I choose a middle-value paper for the majority of my work; there is a nice balance of tonal relationship to start with.

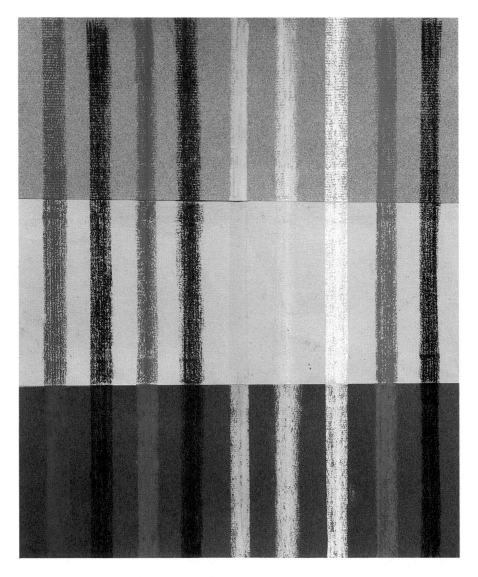

This color chart is made up of three Canson Ingres papers: a medium-value gray, a cream, and a dark green, Nine pastel colors were applied vertically on the paper, each with equal intensity and it is interesting to note how the colors either recede or advance depending on the color of the background paper. On the gray paper with a middle-value tone, practically all the colors are strong and well defined: the blue gray 4 is the least dramatic color there, with the black, white, madder brown 8 (373.3), and Vandyke brown 8 (409.3) vying with each other for dominance. On the cream paper, which has the lightest tone, the light hues—madder brown 0 (399.9), white, and yellow ochre 2 (202.7)—are almost submerged. However the darker pastels appear quite strong, so you would need to use them with caution on this light-toned paper. Finally, the dark green paper shows the opposite effect, with the darker pastels rather muted when compared with the three light pastels: madder brown 0, yellow ochre 2, and white.

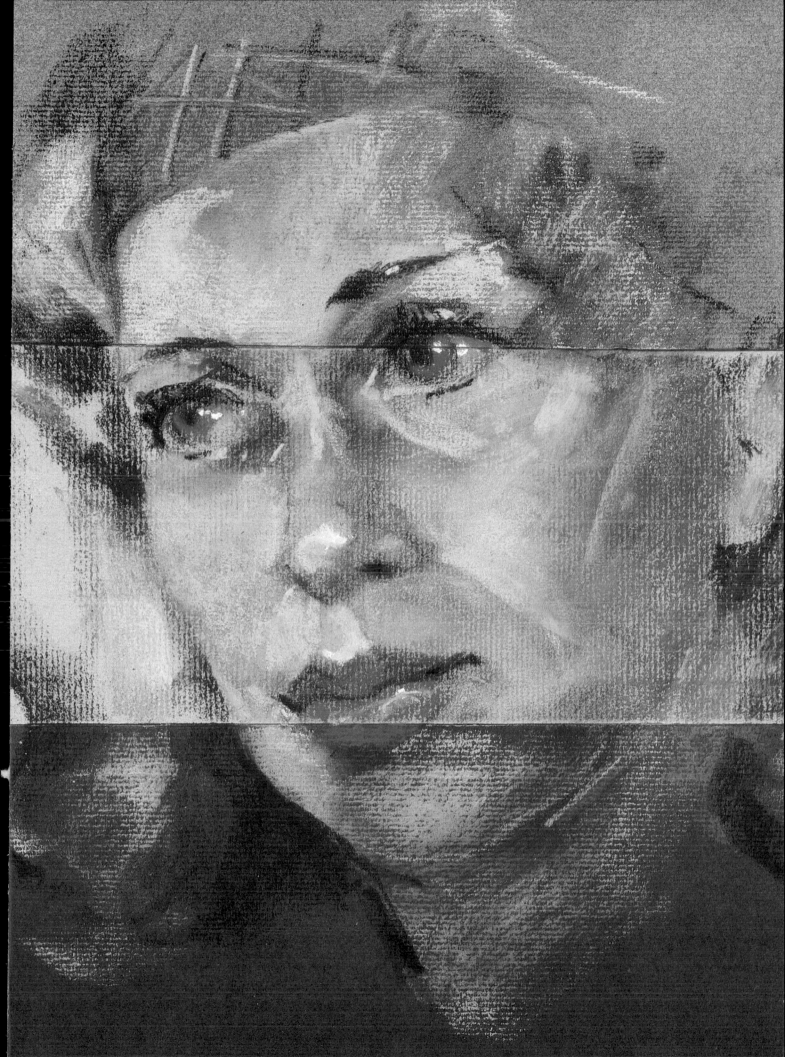

Index